FIFTY YEARS OF COLLECTING: AN ANNIVERSARY SELECTION

PAINTING SINCE WORLD WAR II

Fifty Years of Collecting: An Anniversary Selection

Painting Since World War II

EUROPE

LATIN AMERICA

NORTH AMERICA

by Thomas M. Messer

This exhibition is made possible by a generous grant from The Chase Manhattan Bank.

Alitalia is the official carrier for the presentation.

The Solomon R. Guggenheim Foundation

Library of Congress Cataloging-in-Publication Data

Messer, Thomas M.
 Fifty years of collecting.

 Includes indexes.
 Contents: 1. Painting by modern masters—2. Sculpture
of the modern era—3. Painting since World War II.
 1. Art, Modern—20th century—Exhibitions.
2. Solomon R. Guggenheim Foundation—Exhibitions.
I. Solomon R. Guggenheim Foundation. II. Title.

N6490.M473 1987 709'.04'007401471 87-20763
ISBN 0-89207-064-1 (v. 1)
 0-89207-065-x (v. 2)
 0-89207-066-8 (v. 3)

Published by The Solomon R. Guggenheim Foundation, New York, 1987

Copyright © 1987 by The Solomon R. Guggenheim Foundation, New York

Printed in Italy

cover: cat. no. 1, Latin America, Matta, *Years of Fear*. 1941

TABLE OF CONTENTS

DONORS TO THE COLLECTION
INCLUDED IN THE EXHIBITION

Harry N. Abrams Family Collection

Louis and Bessie Adler Foundation, Inc.

Annika Barbarigos

Stanley and Alice Bard

The Dorothy Beskind Foundation

Mr. Irving Blum

Mr. Jerome Brody

Kevin M. Cahill, M.D.

Joseph Cantor

Mr. and Mrs. Joseph Cantor

C.E.D.E.F., S.A., Geneva

Owen Cheatham Foundation

Enrico and Fiorella Chiari, Venice

Eve Clendenin, New York

Coral Pictures Corporation

The Dannheisser Foundation

Elaine and Werner Dannheisser

Saul and Ellyn Dennison

William C. Edwards, Jr.

Mr. and Mrs. William C. Edwards, Jr.

Mr. Gerald Elliott

Mr. and Mrs. Allan D. Emil

Exxon Corporation

Mrs. Teresita Fontana

Mr. and Mrs. Charles S. Gehrie

Mr. and Mrs. Charles Goldsmith

Peggy Guggenheim

Agnes Gund

Walter K. Gutman

The Merrill G. and Emita E. Hastings Foundation

Susan Morse Hilles

Barbara and Donald Jonas

The Junior Associates

Samuel M. Kootz Gallery

Katharine Kuh

Mr. and Mrs. Peter O. Lawson-Johnston

Mr. and Mrs. Cedric H. Marks

Oscar Maxera

Robert and Meryl Meltzer

Adrian and Robert Mnuchin

Leon A. Mnuchin

Montedison, U.S.A.

National Endowment for the Arts

Fundación Neumann, Caracas, Venezuela

Ramon Osuna III

Gerhard Richter

The Mark Rothko Foundation, Inc.

Mr. and Mrs. James Rudel

Mr. and Mrs. Andrew M. Saul

Denise and Andrew Saul Philanthropic Fund

Mr. and Mrs. Rudolph B. Schulhof

Dr. and Mrs. Natalio Schvartz

Evelyn Sharp

Evelyn Sharp Foundation

Mr. and Mrs. Edward Shufro

Mrs. Leo Simon

Sidney Singer

Mr. and Mrs. Stuart M. Speiser

Dr. Ruth Stephan

Stephen and Nan Swid

The Theodoron Foundation

Jack Tworkov

Paul Waldman

SPONSOR'S STATEMENT

We at Chase are pleased to sponsor the Guggenheim's exhibition of master-works of European and American art, which has been planned as part of the Museum's fiftieth anniversary celebration.

The exhibition offers a broad look at twentieth-century art—from Impressionism through Cubism and Surrealism to Abstract Expressionism and more recent postwar movements—and brings together, for the first time, artworks from the permanent collection of the Guggenheim Museum in New York and from the Peggy Guggenheim Collection in Venice. It is a privilege for us to help bring to public view these outstanding works.

Sponsoring this presentation is just one way we are continuing Chase's partnership with the arts, which has been going strong for thirty years through our philanthropic contributions and our corporate art collection, which contains many works by the artists represented here.

WILLARD C. BUTCHER, *CHAIRMAN OF THE BOARD*
THE CHASE MANHATTAN BANK

PREFACE AND ACKNOWLEDGMENTS

Anniversaries are simultaneously retrospective and prospective occasions. For a brief moment time must have a stop while we assess a momentary and imaginary juncture between what has passed and what may lie ahead. Emphasis and commitment are rightly reserved for the unfathomable future but even its partial intuition depends upon notions derived from the past.

It was fifty years ago that The Solomon R. Guggenheim Foundation, today the parent body of two museums, one in New York and one in Venice, was established, and therefore a half-century span of collecting can be reviewed in this year of 1987. The moment coincides with a manifest need to bring a half-hidden collection into fuller view, and even the very partial success of this endeavor in the Foundation's anniversary year is to us cause for satisfaction while also serving as an augury of future fulfillment.

To reach such goals the Trustees of The Solomon R. Guggenheim Foundation years ago authorized a sizeable enlargement of Museum spaces to be reserved for the presentation of the permanent collection—resulting in an effort that has consumed much of the past decade. Only its first phase has so far been realized, yielding the stage for the collection survey recorded in this publication.

The selection has been drawn from our entire holdings and is divided into three parts, each of which is provided with a separate picture book. The sequence begins with painting by modern masters, shown on two floors on the Museum's north side which have been reconstituted as galleries since the opening of the Frank Lloyd Wright building in 1959. Part of the modern masters presentation is installed in the Thannhauser Wing, which has just been rebuilt, and a new gallery to its east, created within the past year. The presentation's middle section, occupying all but the two top ramps of the grand spiral, has been reserved for sculpture, ranging from its modern origins to the current decade. The remaining ramps, of which the uppermost has been newly reconstructed, presents highlights from the postwar collection of painting in three consecutive chapters beginning with Europe, proceeding with Latin America and ending with North America.

To celebrate the occasion, the finest works from the Peggy Guggenheim Collection have been integrated with the treasures of the Solomon R. Guggenheim Museum, for the first time in New York, thus emphasizing the richness and range of the two collections held in custody by the Foundation whose anniversary is being observed. It should be noted in this context that no loans or even promised gifts are included in the presentation, so that its full significance remains undiluted.

But pride and satisfaction, appropriate sentiments we trust for a commemorative occasion, remain linked to an awareness of persisting insufficiencies. The provisional quality of the gallery spaces, with whatever temporary awkwardness may be apparent in this intermediary building stage, imposes reservations upon our contentment. We are also aware of the need to prune and

enrich the collection in areas of weakness that still prevail—an undertaking increasingly difficult at a time of high prices and low income. But more than a beginning has been made in what must be a continuing process, and the generosity of the Museum's friends in the past justifies optimism as this institution moves into its second half-century.

The first to be thanked in this context are the members of the Foundation's Board of Trustees who, under the Presidency of Peter Lawson-Johnston, have provided essential material and moral support for the acquisition process over an extended period of time. Equally decisive and therefore deserving of gratitude are various past contributions by the Guggenheim's Curatorial staff, in recent years particularly those of Diane Waldman, the Museum's Deputy Director, who has shared with me responsibility for acquisitions in the area of postwar art.

Among the many benefactors to whom we are grateful are the donors of works in the current selection, whose names are listed elsewhere in this catalogue. Thanks must be expressed to the staffs of both the Guggenheim Museum in New York and the Peggy Guggenheim Collection in Venice, which made extraordinary efforts on behalf of the exhibition and catalogues. The most centrally involved at the Solomon R. Guggenheim Museum were Lisa Dennison, Assistant Curator, who coordinated the effort with the assistance of Nina Nathan Schroeder, Curatorial Assistant; Karyn Zieve, National Endowment for the Arts Curatorial Fellow; Carol Fuerstein, Editor; and Diana Murphy, Assistant Editor. At the Peggy Guggenheim Collection Philip Rylands, Deputy Director, and his assistant Renata Rossani provided analogous services.

Our deepest and most sincere appreciation is due to The Chase Manhattan Bank for the generous grant they provided for the exhibition. We are grateful to Alitalia for the transportation of works of art for the presentation. We are indebted to these organizations, as well as to the many other benefactors whose enlightened support has assured the viability of our programs over the years.

THOMAS M. MESSER, *DIRECTOR*
THE SOLOMON R. GUGGENHEIM FOUNDATION

PAINTING SINCE WORLD WAR II

This third installment of the Guggenheim's fiftieth anniversary show is devoted to its collection of painting created during and following the war years. It is likely to be the most controversial part of the tripartite review, largely because the issues and the emotions surrounding the art of our time and of our recent past have not subsided but rather have remained urgently acute. This also means that final evaluations are premature and that revisionist tendencies, relatively marginal in the more distant past, still pose a real threat to any effort to establish a canonical, more or less unanimously acceptable roll call of excellence for the artists of this epoch.

The Guggenheim, at least since the abandonment of its original dogma of non-objectivism in 1952, has never sought to ally itself with stylistic directions, and its institutional preferences have therefore covered a broad range. In keeping with its own traditions, the Foundation has stressed the art of postwar Europe. Interest in contributions from various parts of Latin America, Japan and, in principle at least, from all other parts of the world persists because of a traditional internationalism that has determined the Guggenheim's programming attitudes throughout its fifty-year history. But in the end collecting has been predicated upon a search for quality as this term has been understood by those charged with selections for exhibitions and for acquisition.

The art of the recent past, unlike that of preceding periods, has not yet achieved permanent placement within the Museum, although the proposed building program would provide it. In the meantime, the newly restored top ramp of Wright's spiral, at times in conjunction with the ramp below it, will serve on this anniversary occasion to present painting produced since World War II in three successive sequences devoted, respectively, to Europe, Latin America and North America. In all of these, but particularly in the installations of the postwar painting of Europe and North America, collecting emphases are quite visible and may be seen as Guggenheim preferences. The regrettable absence from the collection of first-rate examples by such artists as de Staël, Balthus, Newman and Johns, however, must not be mistaken for lack of conviction but ascribed to the chronic shortage of funds that has hampered systematic collecting in recent decades. The acquisition of such works remains an urgent objective which the Foundation confidently expects to achieve. In contemporary as well as in earlier periods museum collections come together slowly. Commitment, opportunity and funds have combined in the past to fulfill the Guggenheim's aspirations. We are confident that the same constellation will safeguard the collection's growth and deepening in the future.

TMM

CATALOGUE

The three parts of the exhibition *Painting Since World War II: Europe, Latin America, North America* are presented successively during the course of The Solomon R. Guggenheim Foundation's fiftieth anniversary celebration. The subdivisions of the catalogue correspond to these three installments.

The first number cited in the final line of the caption for each illustration is the Solomon R. Guggenheim Museum or the Peggy Guggenheim Collection acquisition number. The two-digit prefix in these numbers represents the year the work entered the collection. The citations SRGM coll. cat., PGC cat., SRGM hb. and PGC hb. refer to entries in the following publications: *The Guggenheim Museum Collection: Paintings 1880–1945*, New York, 1976; *Peggy Guggenheim Collection, Venice, The Solomon R. Guggenheim Foundation, New York*, New York, 1985; *Handbook: The Guggenheim Museum Collection, 1900–1980*, New York, 1980 and 1984; and *Handbook: Peggy Guggenheim Collection*, New York, 1986.

EUROPE

INDEX OF ARTISTS

Jean Dubuffet

1 *Archetypes (Archétypes).* May **1945**
 Sand, pebbles and paint on canvas, 39⅜ x 31¾ in. (100 x 81 cm.)
 74.2075

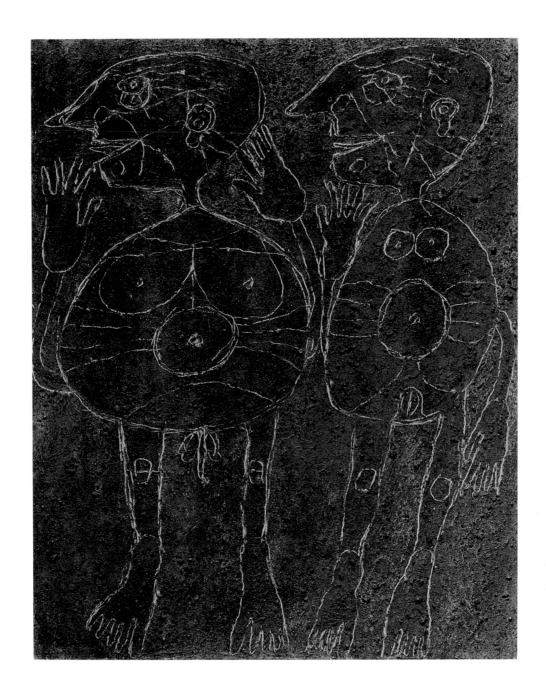

Jean Dubuffet

2 *Miss Cholera.* January **1946**
 Oil, sand, pebbles and straw on canvas, 21½ x 18 in. (54.6 x 45.7 cm.)
 Gift, Katharine Kuh
 72.2007

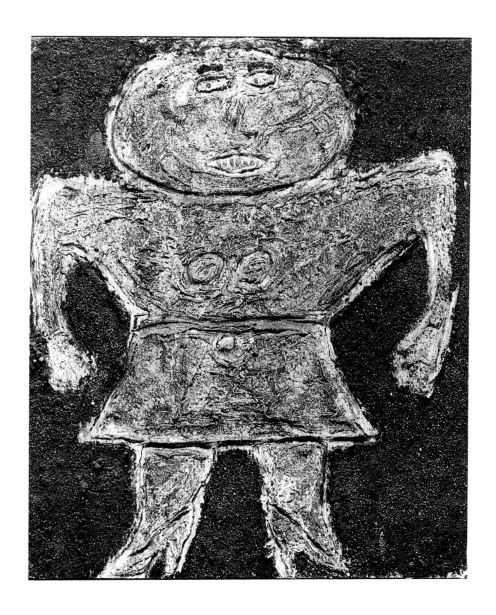

Jean Dubuffet

3 *Will to Power (Volonté de puissance).* January **1946**
 Oil, pebbles, sand and glass on canvas, 45¾ x 35 in. (116.2 x 88.9 cm.)
 74.2076; SRGM hb. 162

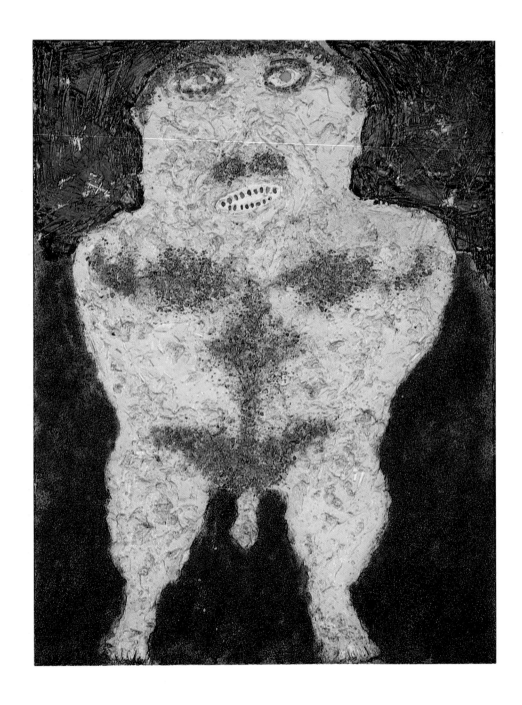

Jean Dubuffet

4 *Triumph and Glory (Triomphe et gloire).* December **1950**
 Oil on canvas, 51 x 38 in. (129.5 x 96.5 cm.)
 71.1973; SRGM hb. 163

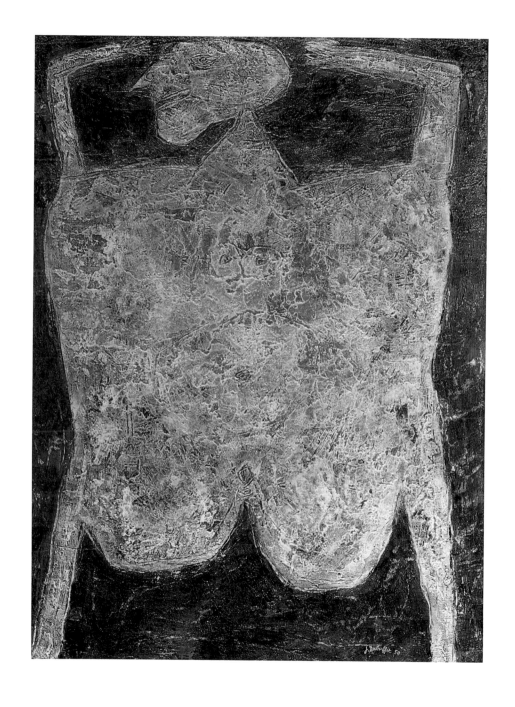

Hans Hartung

5 *T-50 Painting 8 (T-50 Peinture 8).* 1950
 Oil on canvas, 38⅛ x 57½ in. (96.8 x 146 cm.)
 54.1367

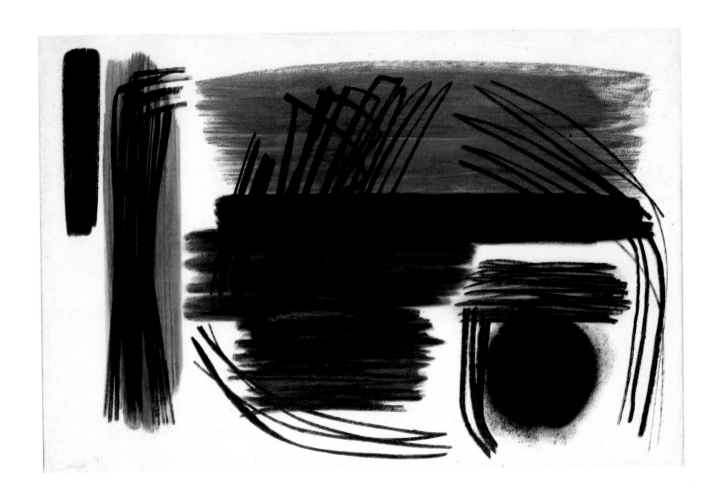

Jean Dubuffet

6 *Knoll of Visions (La Butte aux visions).* August 23, **1952**
 Oil on Masonite, 59 x 76¾ in. (150 x 195 cm.)
 75.2077

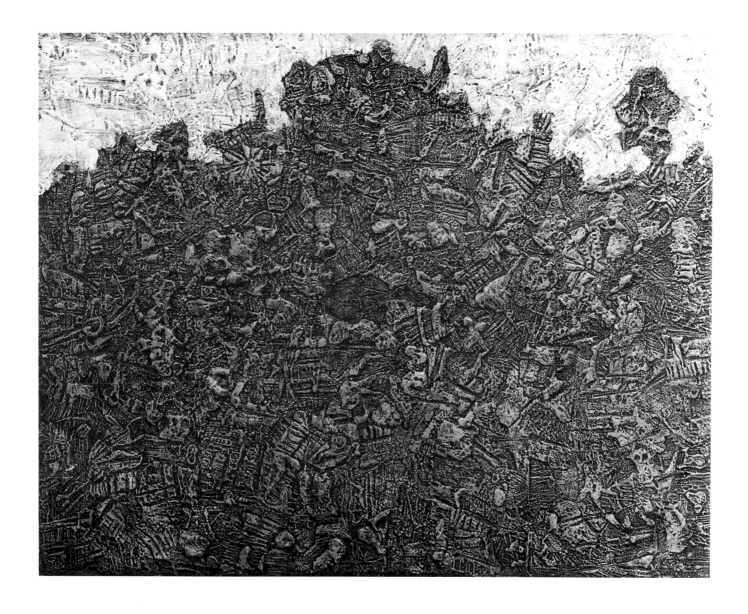

Alberto Giacometti

7 *Diego.* 1953
 Oil on canvas, 39½ x 31¾ in. (100.5 x 80.5 cm.)
 55.1431; SRGM hb. 137

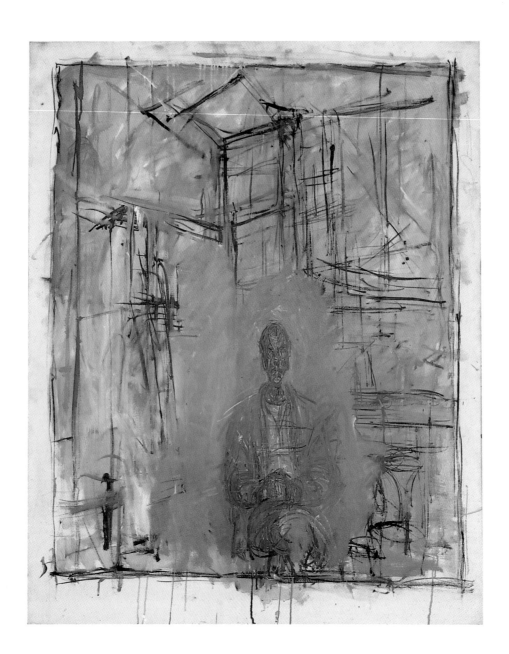

Alberto Burri

8 *Composition (Composizione).* **1953**
 Oil, gold paint and glue on burlap and canvas, 33⅞ x 39½ in. (86 x
 100.4 cm.)
 53.1364; SRGM hb. 176

Pierre Soulages

9 *Painting (Peinture).* May **1953**
 Oil on canvas, 77⅜ x 51¼ in. (196.5 x 129.9 cm.)
 53.1381

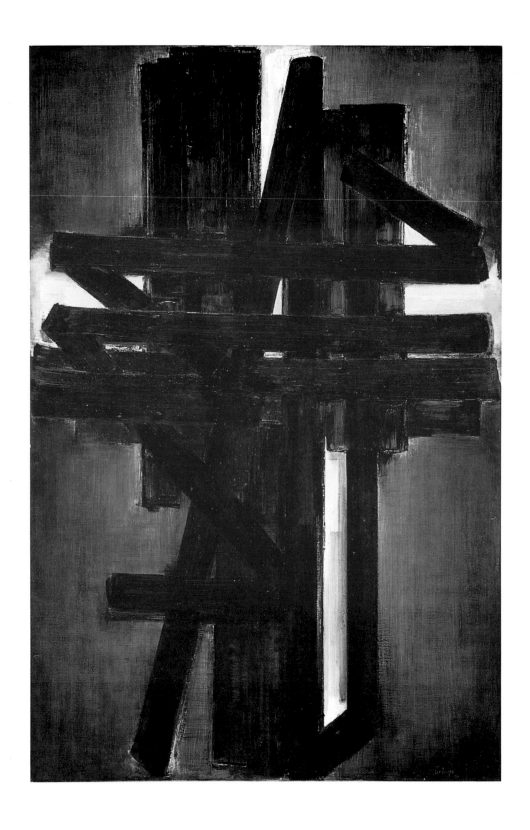

Karel Appel

10 *Two Heads (Deux Têtes).* 1953
 Oil on canvas, 78¾ x 29½ in. (200 x 75 cm.)
 54.1363; SRGM hb. 168

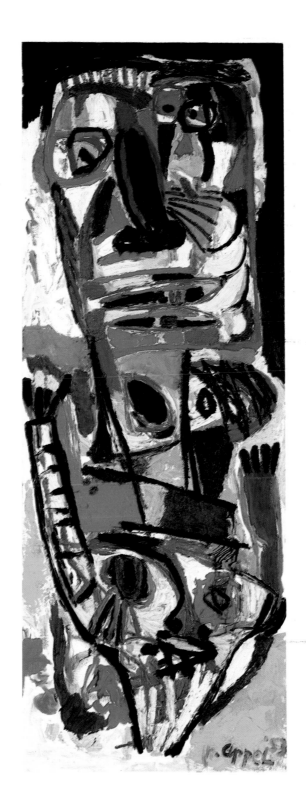

Jean Dubuffet

11 *Door with Couch Grass (Porte au chiendent).* October 31, **1957**
 Oil on canvas with assemblage, 74½ x 57½ in. (189.2 x 146 cm.)
 59.1549; SRGM hb. 164

Asger Jorn

12 *A Soul for Sale (Ausverkauf einer Seele).* 1958–59
Oil on canvas, 79 x 98¾ in. (200 x 250 cm.)
Purchased with funds contributed by the Evelyn Sharp Foundation
83.3040

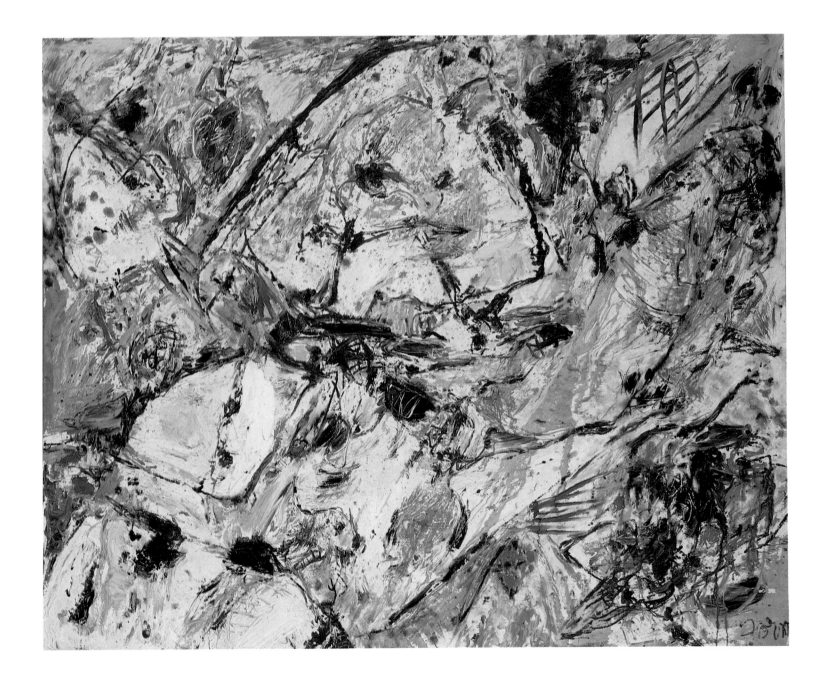

André Masson

13 *Errance I.* 1959
 Tempera on canvas, 51 x 37⅞ in. (130 x 97 cm.)
 Gift, Mr. and Mrs. Allan D. Emil
 80.2709

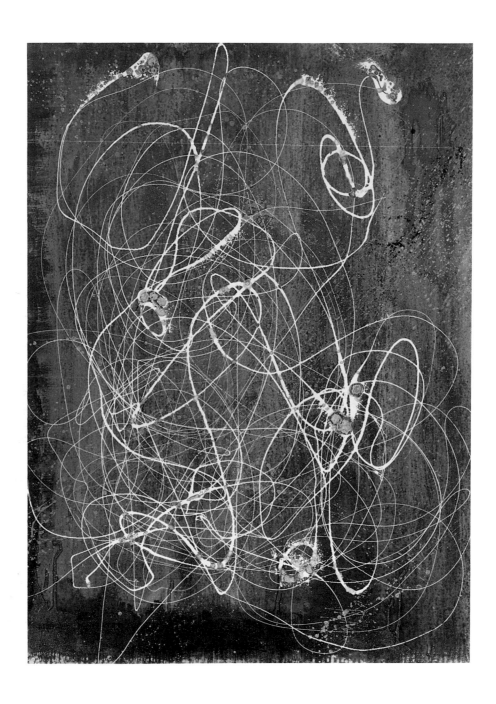

Lucio Fontana

14 *Spatial Conception, Expectations (Concetto spaziale, attese).* 1959
Water-base paint on canvas, 49⅝ x 98¾ in. (126 x 250.9 cm.)
Gift, Mrs. Teresita Fontana
77.2322; SRGM hb. 175

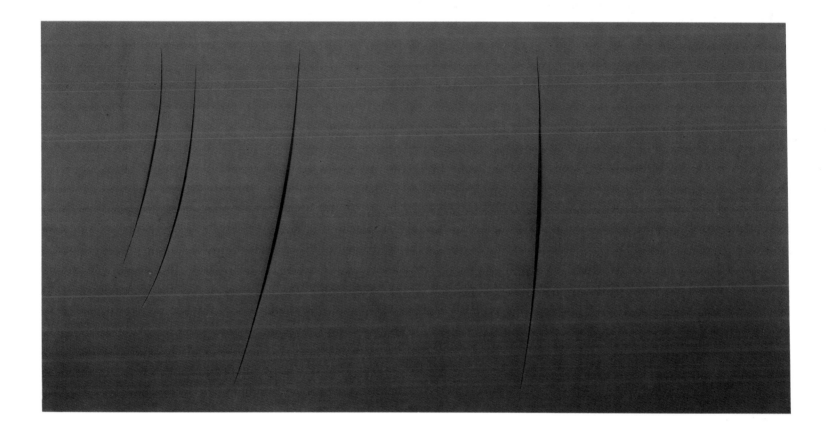

Emil Schumacher

15 *Florian.* 1960
 Oil on wood, 47⅞ x 80 in. (121.6 x 203.2 cm.)
 Gift, Samuel M. Kootz Gallery
 62.1615

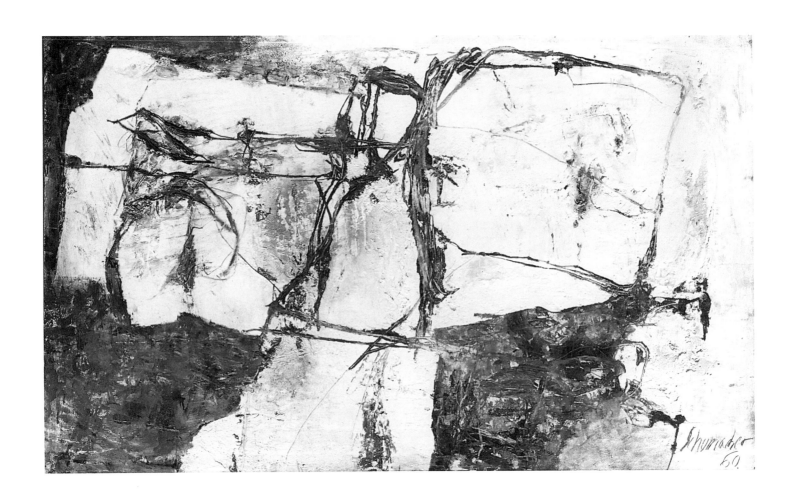

Kurt R. H. Sonderborg

16 *Untitled.* **1961**
 Tempera on paper mounted on canvas, 43 x 27⅝ in. (109.3 x 70.2 cm.)
 63.1646

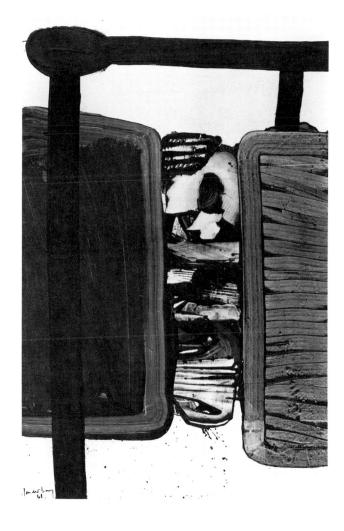

Jean Dubuffet

17 *Propitious Moment (L'Instant propice).* January 2-3, **1962**
 Oil on canvas, 78¾ x 65 in. (200 x 165 cm.)
 74.2080

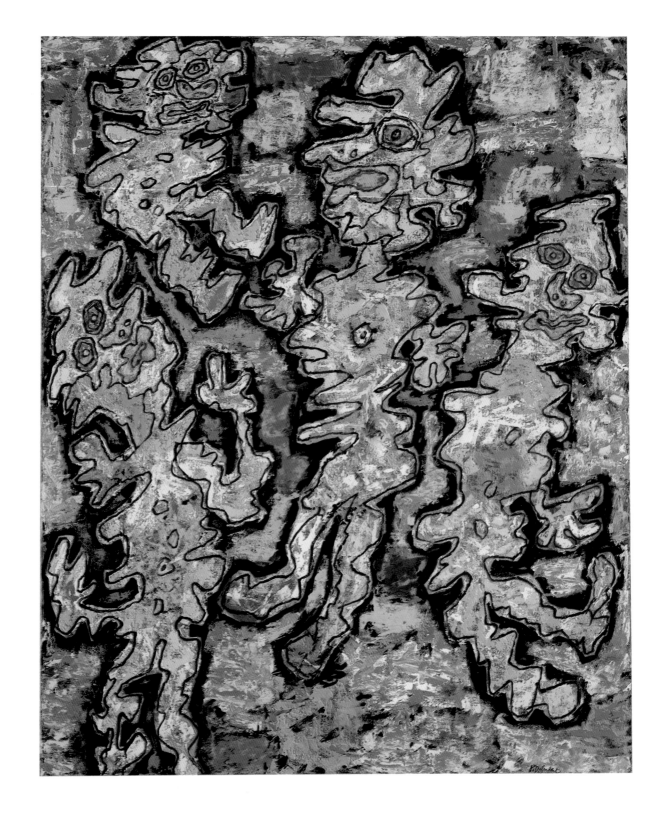

Francis Bacon

18 *Three Studies for a Crucifixion.* March **1962**
Oil with sand on canvas, 3 panels, each 78 x 57 in. (198.2 x 144.8 cm.)
64.1700.a–.c; SRGM hb. 161

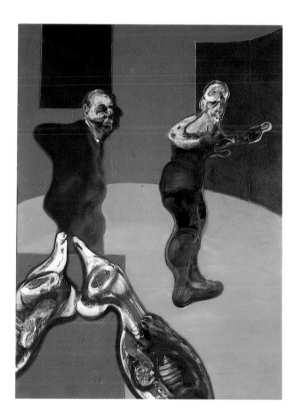
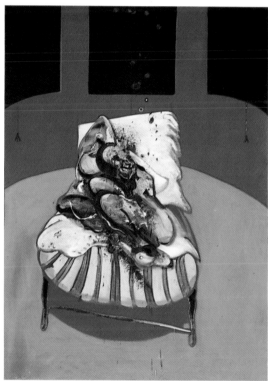
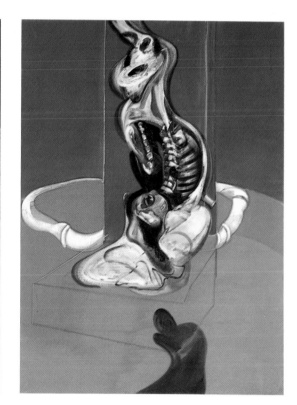

Jean Dubuffet

19 *Nunc Stans*. May 16–June 5, **1965**
 Vinyl on canvas, 3 panels, each 63¾ x 107⅞ in. (161.9 x 274 cm.); total
 64⅛ x 323½ in. (162.8 x 821.7 cm.)
 66.1818; SRGM hb. 165

Richard Hamilton

20 *The Solomon R. Guggenheim (Black); (Black and White);* **36**
 (Spectrum). **1965–66**
 Fiberglas and cellulose, 3 reliefs, each 48 x 48 x 7½ in. (122 x 122 x
 19 cm.)
 67.1859.a–.c; SRGM hb. 183

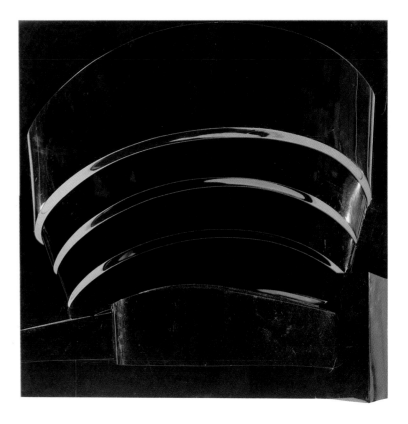

Roman Opalka

21 *1965–1–Detail 1,520,432–1,537,871.* 1965
 Acrylic on canvas, 77¼ x 53¼ in. (196.2 x 135.2 cm.)
 76.2220

Victor Vasarely

22 *Reytey.* 1968
 Tempera on canvas, 63 x 63 in. (160 x 160 cm.)
 73.2042; SRGM hb. 180

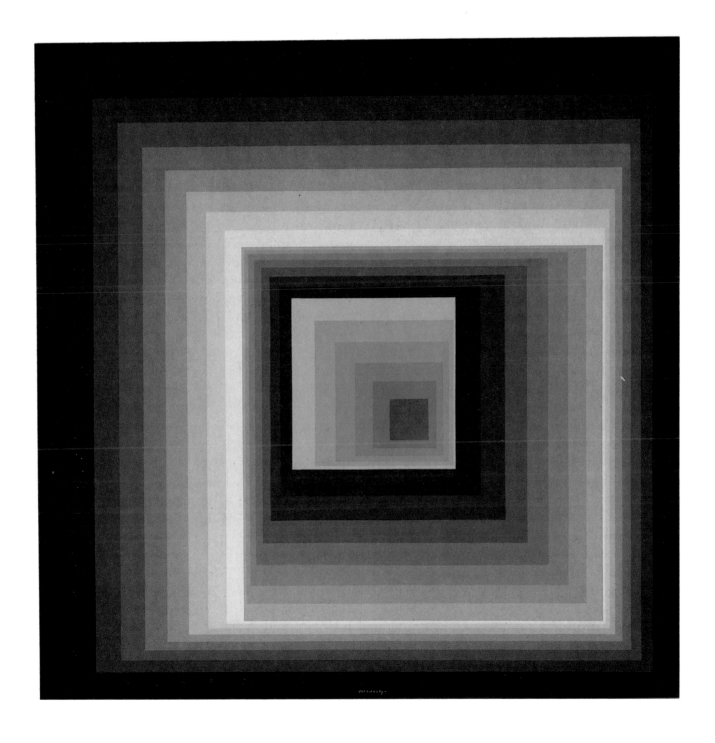

Gerhard Richter

23 *Passage (Durchgang).* 1968
 Acrylic on canvas, 78¾ x 78¾ in. (200 x 200 cm.)
 Purchased with funds contributed by The Theodoron Foundation
 69.1904

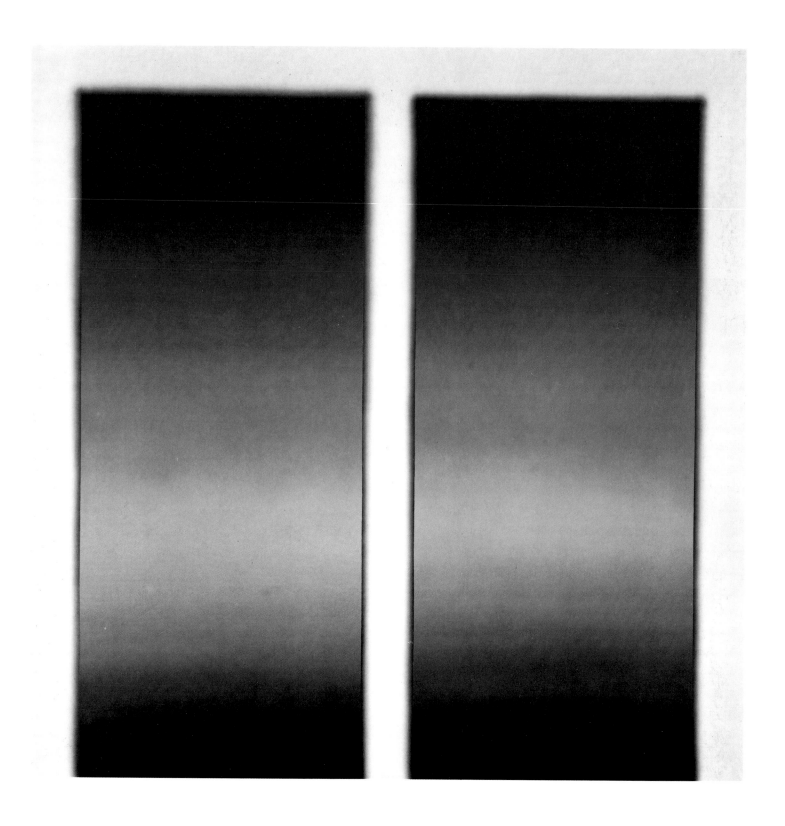

Horst Antes

24 *Large Black Figure (Grosse schwarze Figur).* **1968**
 Aquatec, charcoal and masking tape on canvas, 59 x 47⅜ in. (105.5 x
 120.3 cm.)
 69.1880; SRGM hb. 185

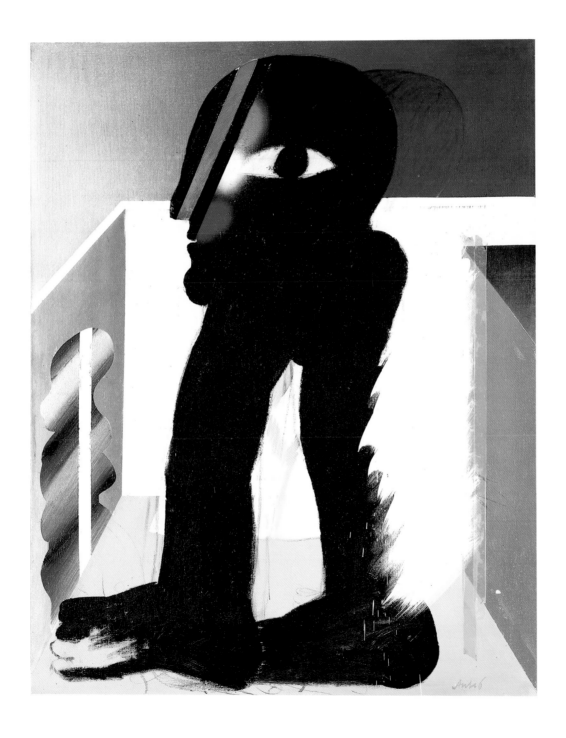

Max Bill

25 *Parallels of Double Colors in Space (Parallelen im*
 Raum aus Doppelfarben). **1970–73**
 Oil on canvas (lozenge), 83 ½ x 83 ½ in. (211.5 x 211.5 cm.)
 Purchased with funds contributed by William C. Edwards, Jr., in memory
 of Sibyl
 81.2784

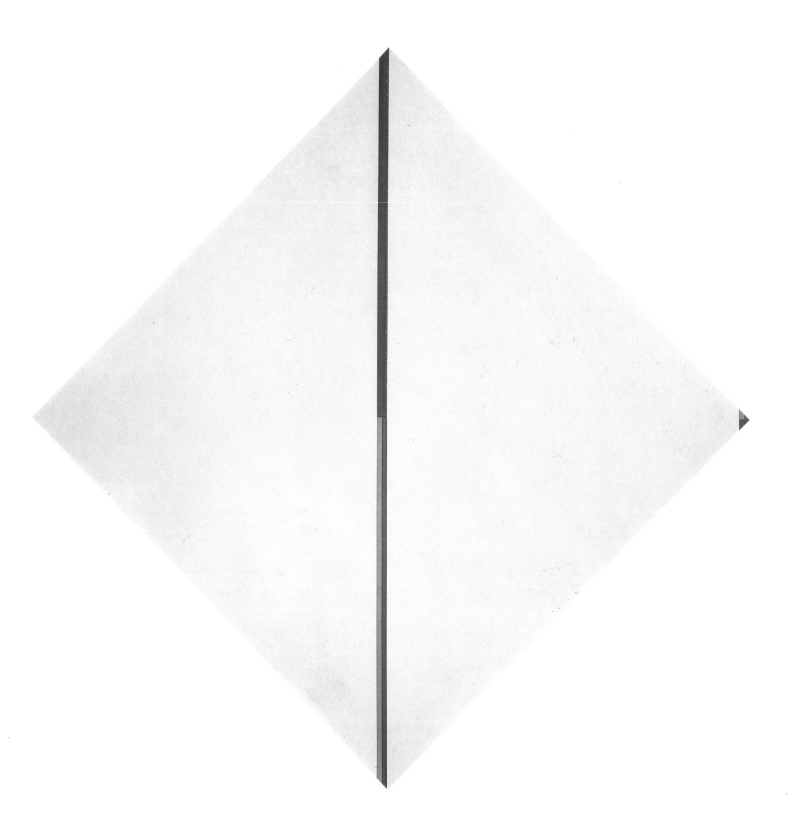

Pierre Alechinsky

26 *Aztec Volcano (Volcan aztèque).* **1971**
Acrylic with marginal drawings in watercolor on paper mounted on
canvas, 61⅛ x 79¼ in. (155.2 x 201.2 cm.)
Peggy Guggenheim Collection, Venice, The Solomon R. Guggenheim
Foundation, Gift, Enrico and Fiorella Chiari
84.3253

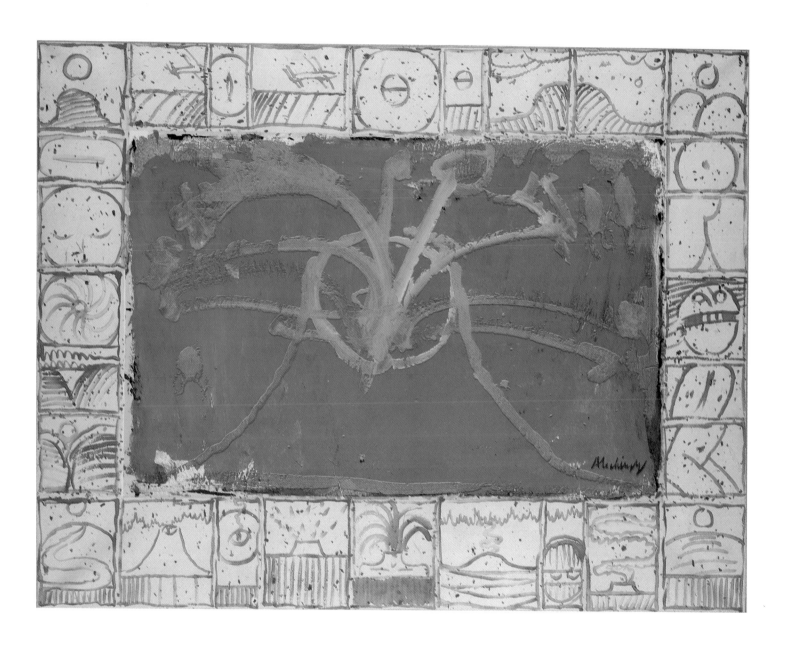

Arnulf Rainer

27 *Untitled*. 1974
 Oil on photo linen, 66¾ x 47¼ in. (170 x 120 cm.)
 Gift, Montedison, U.S.A.
 86.3418

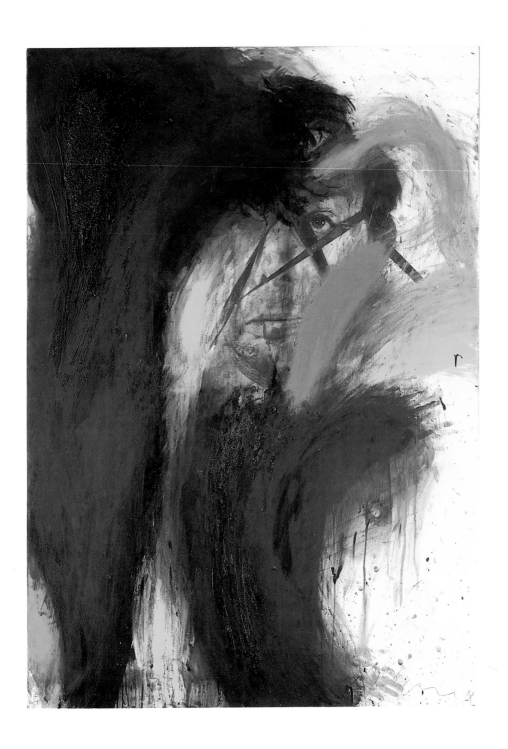

Antoni Tàpies

28 *Large Brown Diptych (Gran diptico marró).* **1978**
Oil, sand, chalk and plaster on wood, 2 panels, each 76¾ x 66⅞ in.
(195 x 169.8 cm.); total 76¾ x 133⅝ in. (195 x 339.4 cm.)
Gift, Mr. and Mrs. Rudolph B. Schulhof
86.3493

Georg Baselitz

29 *The Gleaner (Die Aehrenleserin).* August **1978**
 Oil and tempera on canvas, 130 x 98⅜ in. (330.4 x 249.9 cm.)
 Purchased with funds contributed by Robert and Meryl Meltzer
 87.3508

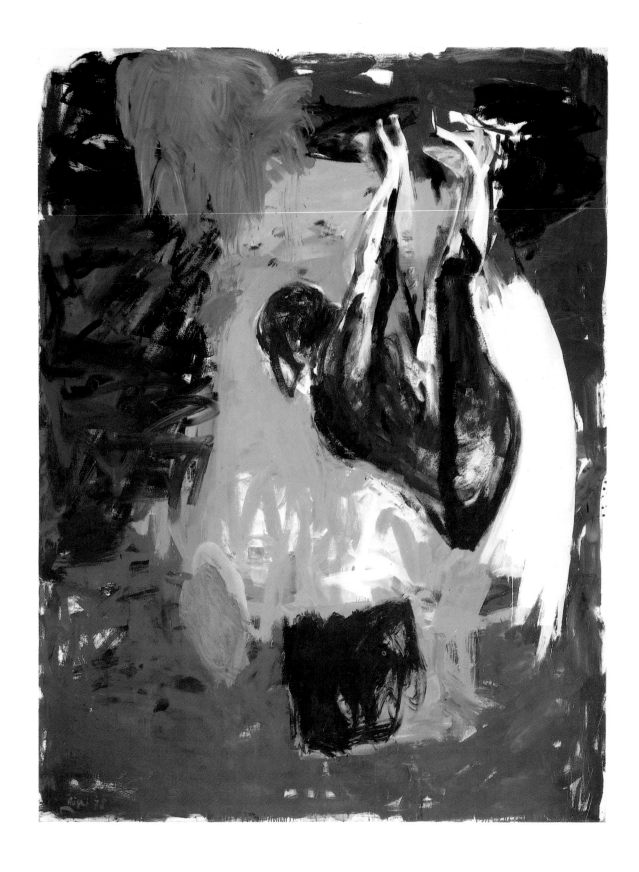

Richard Smith

30 *Working Week 5 (for Charles Mingus).* **1979**
 Acrylic and polyurethane on canvas, 106 x 146 in. (269.2 x 370.8 cm.)
 Partial gift, Mr. and Mrs. William C. Edwards, Jr.
 80.2680.a–.e

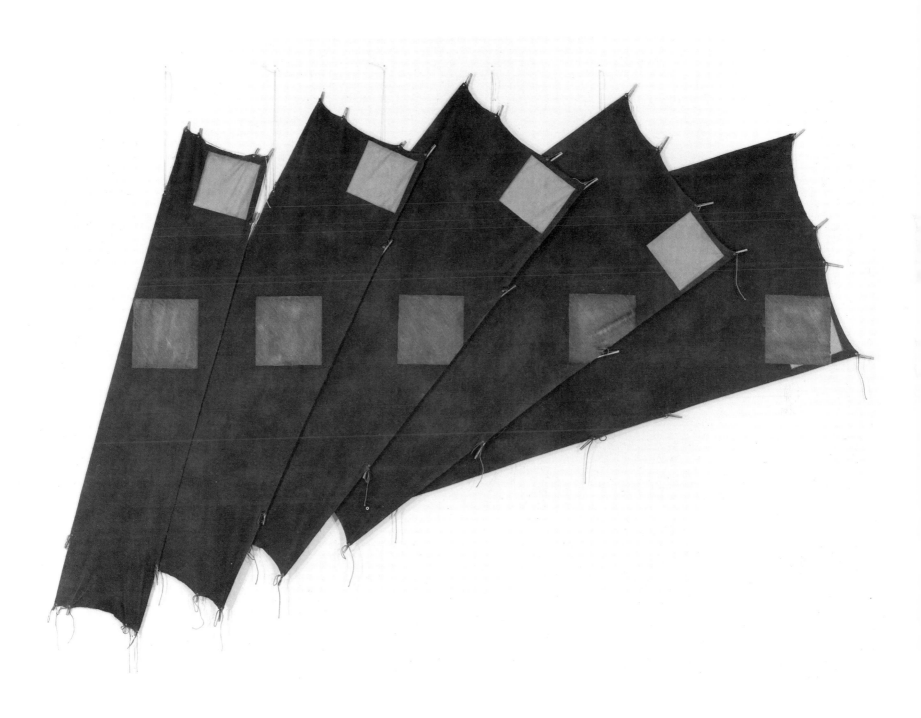

Pierre Alechinsky

31 *Codex.* 1981
 Acrylic with acrylic border on paper mounted on canvas, 60½ x 118 in.
 (153.5 x 300 cm.)
 Gift, Mr. Jerome Brody
 85.3280

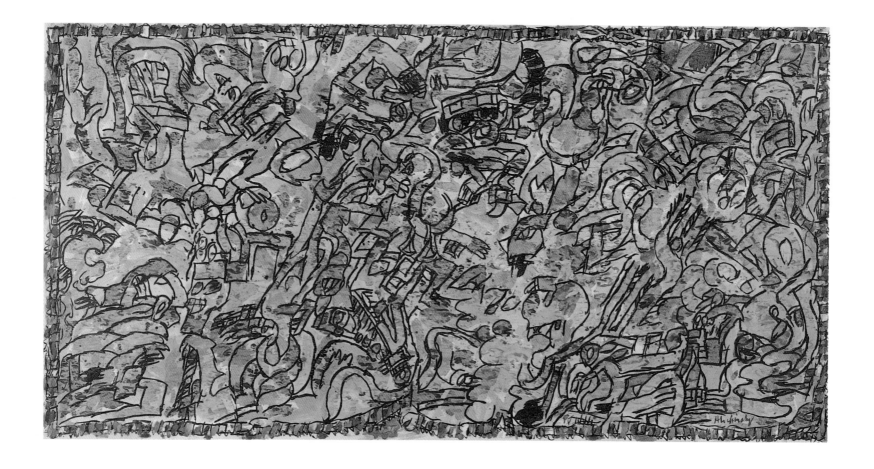

Enzo Cucchi

32 *The Mad Painter (Il pittore matto).* 1981–82
Oil on canvas, 119½ x 83¾ in. (303.5 x 212.7 cm.)
Exxon Corporation Purchase Award with additional funds contributed
by The Junior Associates
82.2927

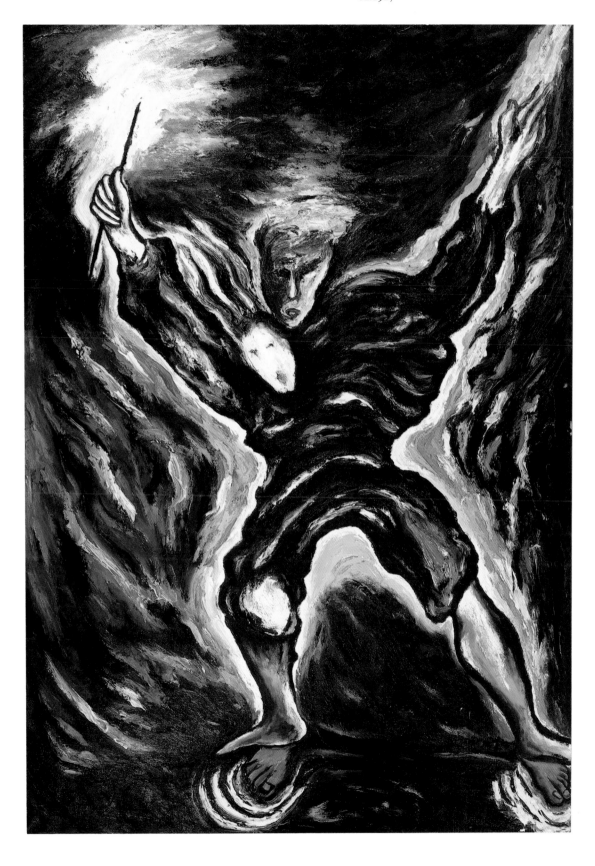

Sandro Chia

33 *Running Men.* 1982
Oil on canvas, 79¼ x 144 in. (201.3 x 367 cm.)
Exxon Corporation Purchase Award with additional funds contributed
by Adrian and Robert Mnuchin and Barbara and Donald Jonas
82.2926

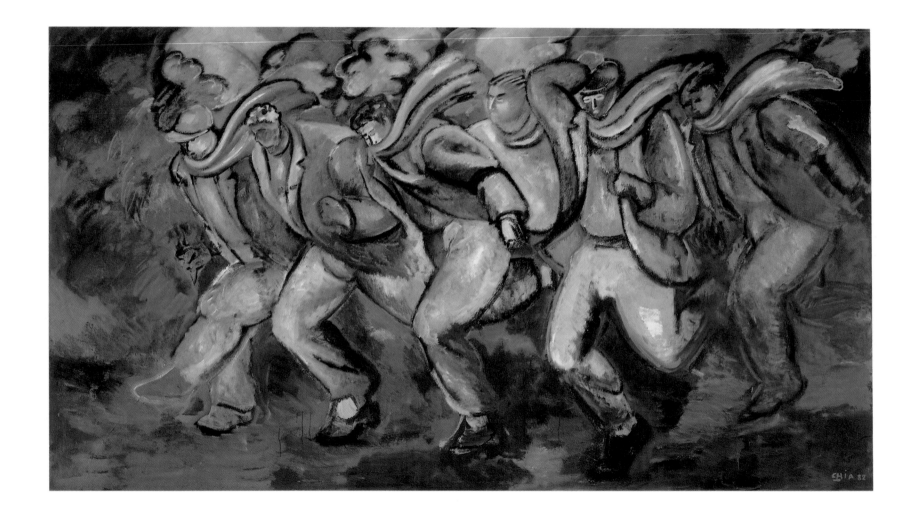

Darío Villalba

34 *Holy Week (Semana santa).* 1982
Oil and mixed media on canvas, 3 panels, each 78¾ x 63 in. (200 x 160 cm.); total 78¾ x 189 in. (200 x 480 cm.)

Purchased with funds contributed by The Merrill G. and Emita E. Hastings Foundation

82.2945.a–.c

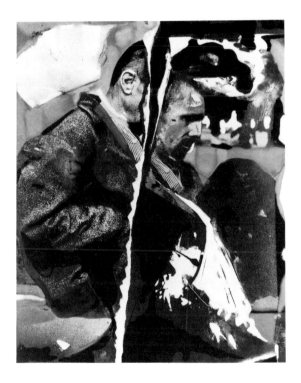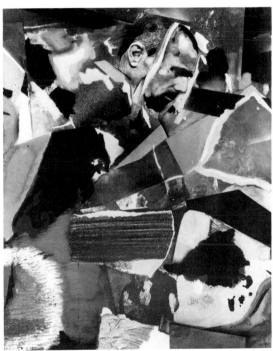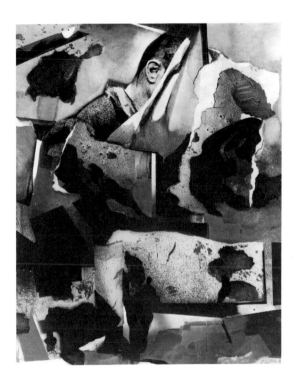

Louis le Brocquy

35 *Study Towards an Image of William Shakespeare.* 1982
Oil on canvas, 31¼ x 31¼ in. (79.4 x 79.4 cm.)
Gift, Kevin M. Cahill, M.D.
84.3160

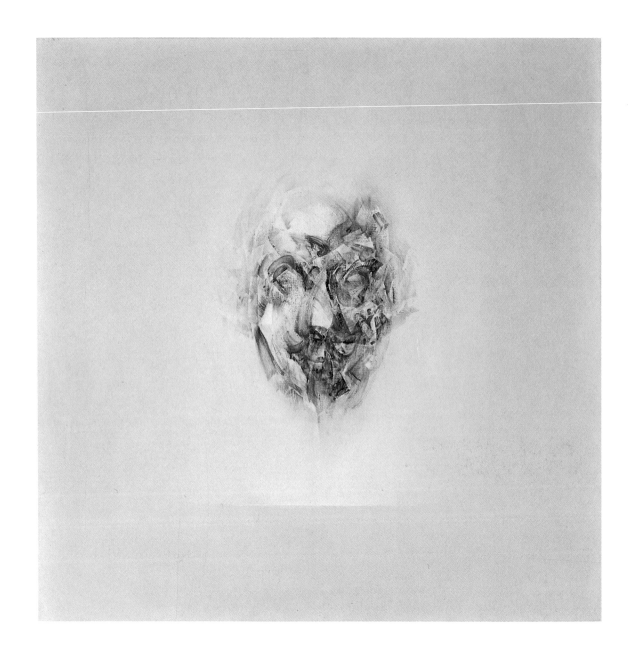

Louis le Brocquy

36 *Study Towards an Image of William Shakespeare.* 1982
 Oil on canvas, 31¼ x 31¼ in. (79.4 x 79.4 cm.)
 Gift, Kevin M. Cahill, M.D.
 84.3161

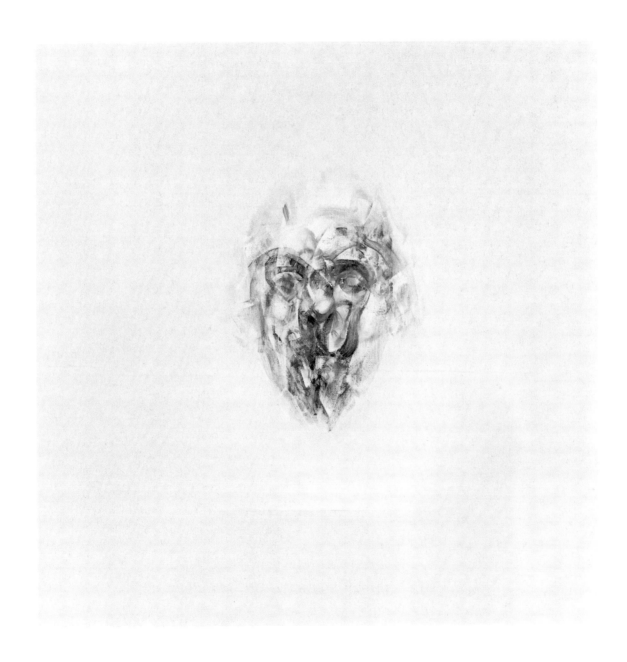

Jan Dibbets

37 *Octagon I.* **1982**

Color photographs, watercolor and pencil on paper mounted on board,
72¼ x 73 in. (183 x 185 cm.)

Purchased with funds contributed by Stephen and Nan Swid

84.3170

38 *Korn.* 1982
 Oil on canvas, 98¼ x 78¾ in. (205.2 x 201 cm.)
 Gift of the artist
 84.3195

Jean Dubuffet

39 *Mire G132 (Kowloon).* September 18, **1983**
 Acrylic on canvas-backed paper, 79 x 118 in. (200.7 x 299. 8 cm.)
 87.3526

Anselm Kiefer

40 *Seraphim.* **1983–84**
Oil, straw, emulsion and shellac on canvas, 126½ x 130¼ in.
(320.7 x 330.8 cm.)
Purchased with funds contributed by Mr. and Mrs. Andrew M. Saul
84.3216

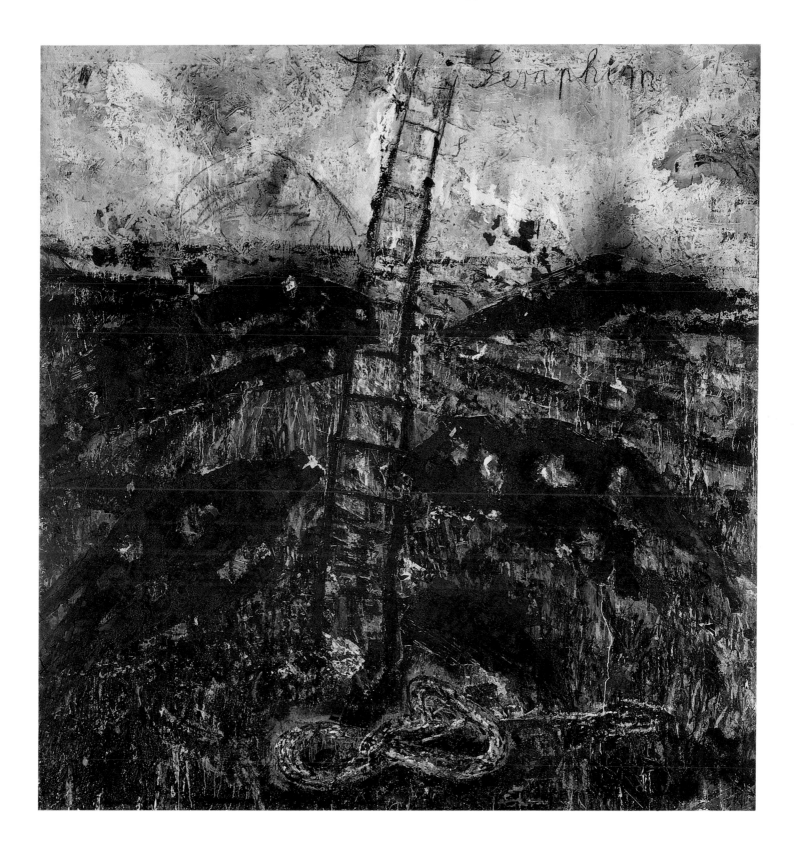

Gilbert and George

41 *Dream.* 1984
 Photo piece, 95¼ x 100 in. (242 x 252 cm.)
 Gift, C.E.D.E.F., S.A., Geneva
 86.3412

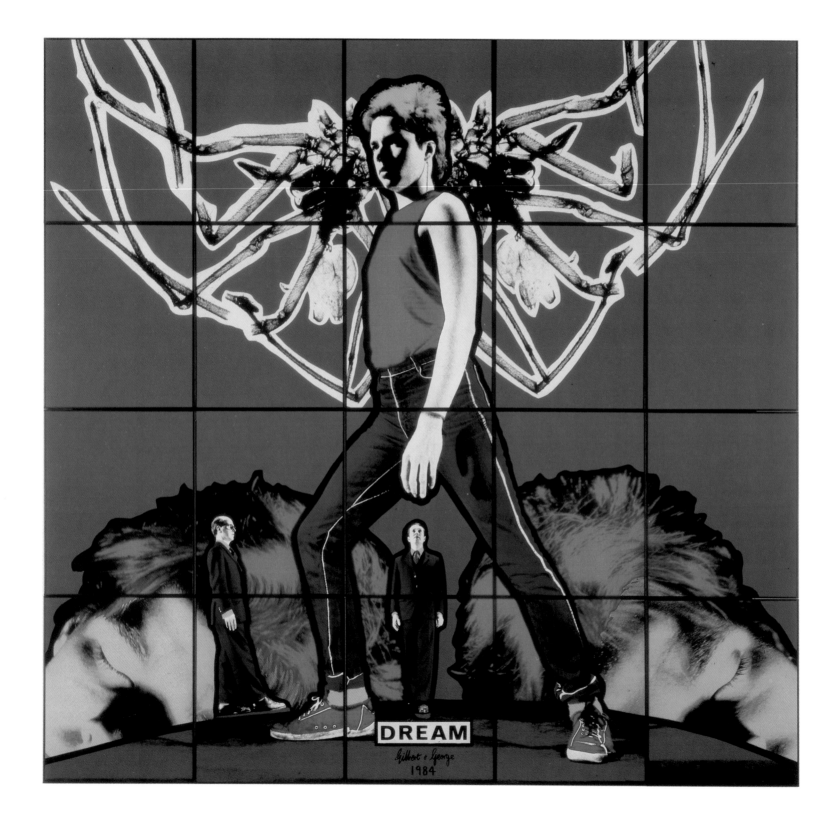

42 *Chancay Suite/Painting No. 11 (Suite Chancay/Peinture no. 11).* **1985**
Oil with wood relief on canvas, 51 x 76⅜ in. (129.5 x 195.3 cm.)
86.3423

Enzo Cucchi

43 *Untitled.* **1986**
 Oil and sheet iron on canvas, 141⅞ x 182 in. (360.4 x 462.3 cm.)

Purchased with funds contributed in part by the Louis and Bessie Adler
Foundation, Inc., Seymour M. Klein, President, the Owen Cheatham
Foundation, Saul and Ellyn Dennison and Mr. Gerald Elliott
86.3448

Jannis Kounellis

44 *Untitled.* 1987
Lead, wax and metal shelf, 79 x 71 x 7½ in. (200.7 x 180.5 x 19 cm.)
Gift, Annika Barbarigos
87.3515

LATIN AMERICA

INDEX OF ARTISTS

Matta (Roberto Sebastian Antonio Matta Echaurren)

1 *Years of Fear.* **1941**
 Oil on canvas, 44 x 56 in. (111.8 x 142.2 cm.)
 72.1991; SRGM hb. 149

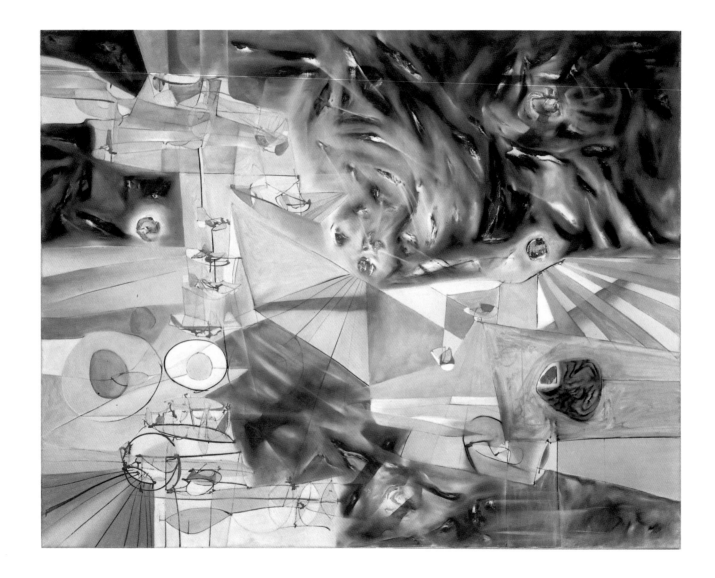

Joaquín Torres-García

2 *Constructive City with Universal Man (Ciudad constructiva con hombre universal).* **1942**
 Oil on board, 31⅝ x 39⅞ in. (79.4 x 101.5 cm.)
 Partial gift, Mr. and Mrs. James Rudel
 84.3167

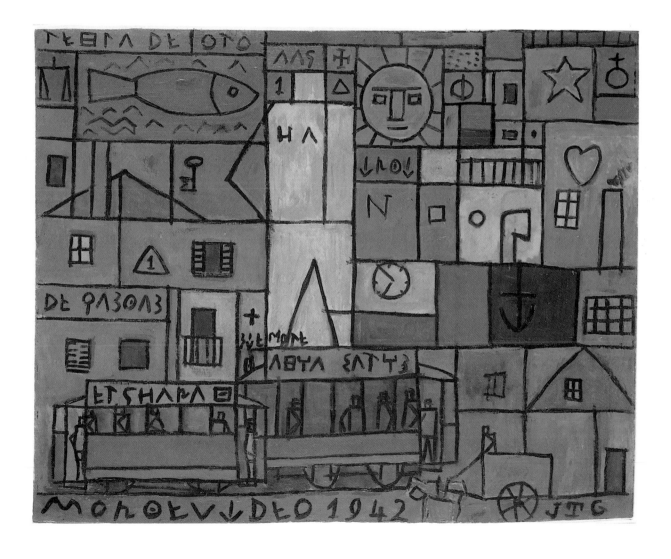

Rufino Tamayo

3 *Heavenly Bodies.* **1946**
 Oil with sand on canvas, 34 x 42¼ in. (86.3 x 170.2 cm.)
 Peggy Guggenheim Collection, Venice, The Solomon R. Guggenheim
 Foundation
 76.2553 PG 119; PGC cat. 165; PGC hb. 131

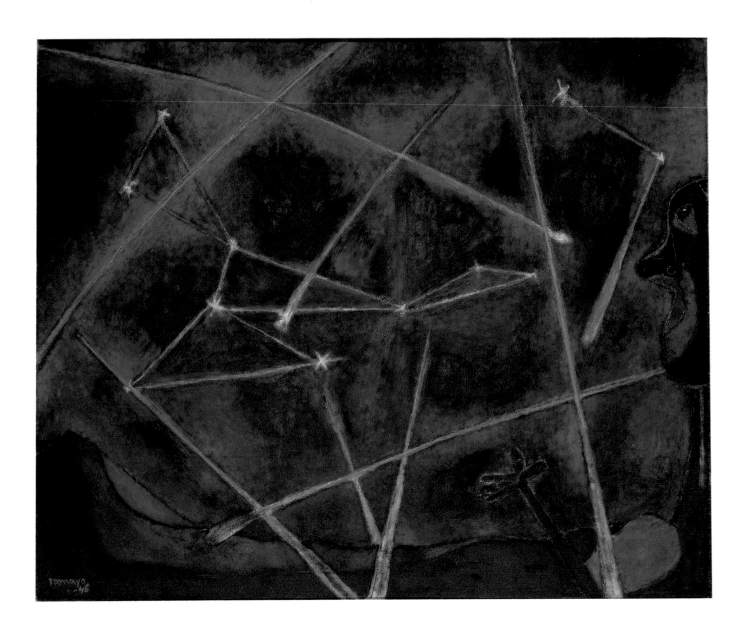

Matta (Roberto Sebastian Antonio Matta Echaurren)

4 *Each And (Chaque et).* 1947
Oil on canvas, 36 x 52 in. (91.2 x 132 cm.)
Gift, Dr. Ruth Stephan
65.1771

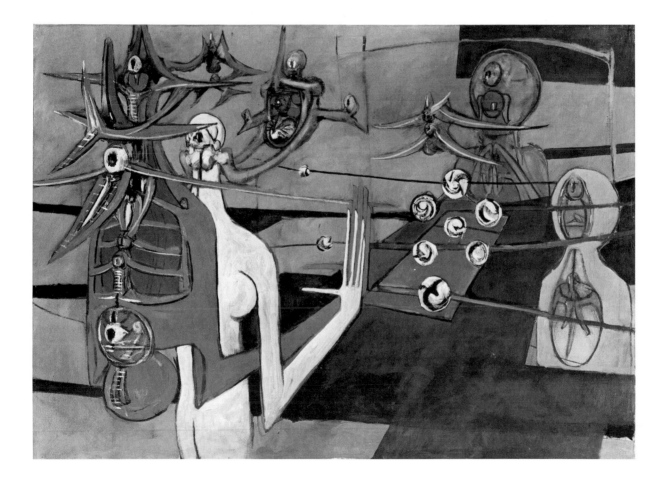

Wifredo Lam

5 *Rumblings of the Earth (Rumor de la tierra).* **1950**
 Oil on canvas, 59¾ x 112 in. (151.7 x 284.5 cm.)
 Gift, Mr. and Mrs. Joseph Cantor
 58.1525; SRGM hb. 152

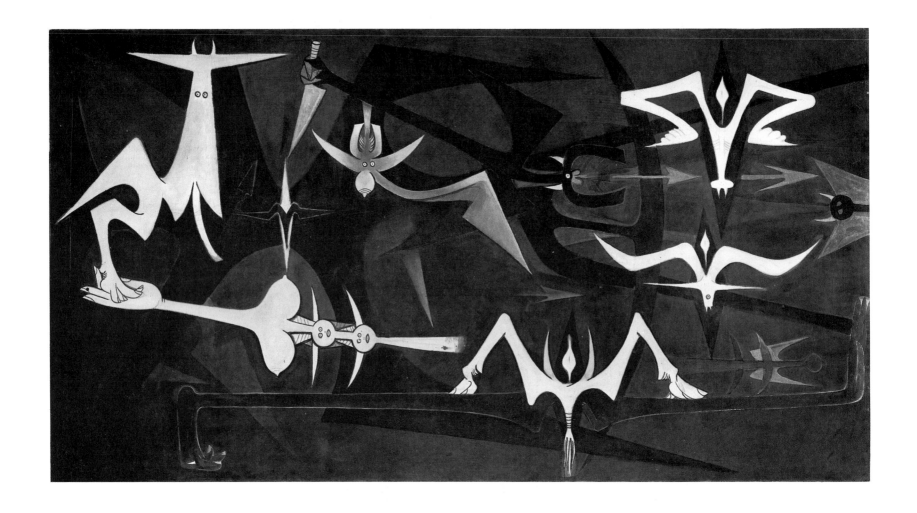

Wifredo Lam

6 *Zambezia, Zambezia.* 1950
 Oil on canvas, 49⅜ x 43⅝ in. (125.4 x 110.8 cm.)
 Gift, Joseph Cantor
 74.2095

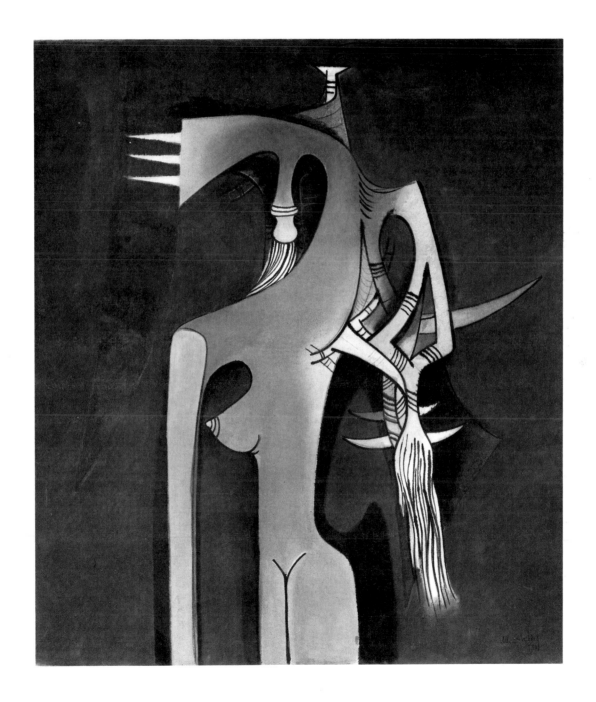

Rufino Tamayo

7 *Woman in Grey (Mujer en gris).* 1959
 Oil on canvas, 76¾ x 51 in. (195 x 129.5 cm.)
 59.1563; SRGM hb. 153

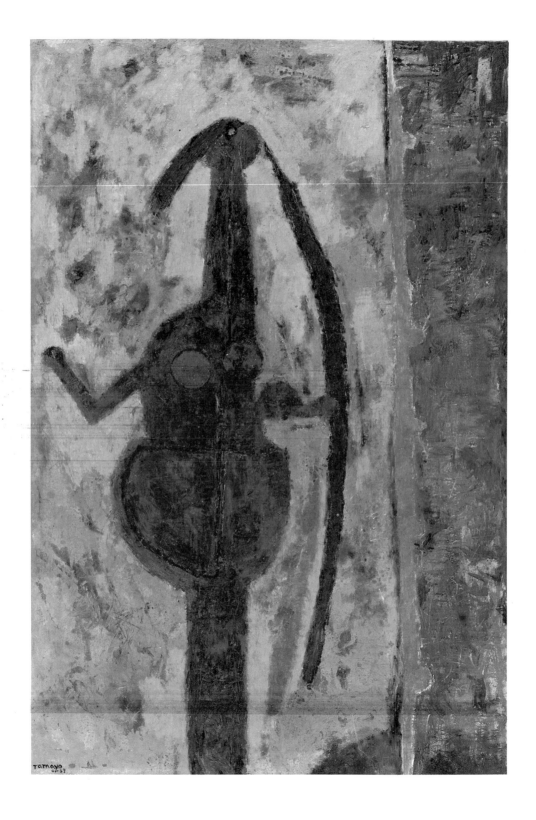

Fernando Botero

8 *Rubens' Wife (La mujer de Rubens).* **1963**
 Oil on canvas, 72⅛ x 70⅛ in. (183.1 x 178.1 cm.)
 Purchased with funds contributed by Fundación Neumann, Caracas,
 Venezuela
 66.1815

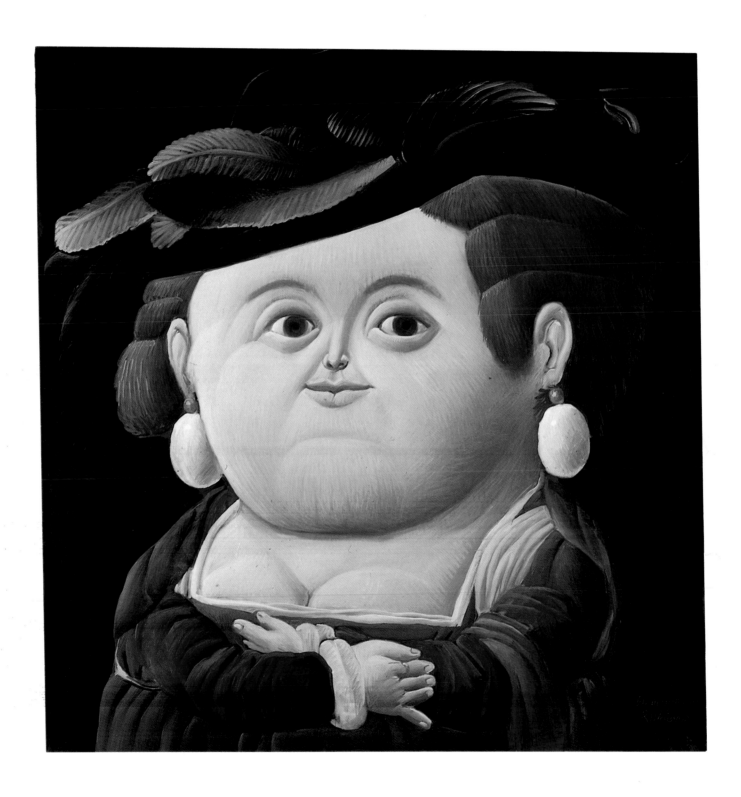

Luis Felipe Noé

9 *Charisma.* **1963**
Collage on canvas, 2 panels, top 57½ x 76¾ in. (146 x 195 cm.), bottom
51⅛ x 76¾ in. (129.9 x 195 cm.); total 108¾ x 76¾ in. (276.2 x
195 cm.)
Gift, Mr. and Mrs. Charles S. Gehrie
64.1728

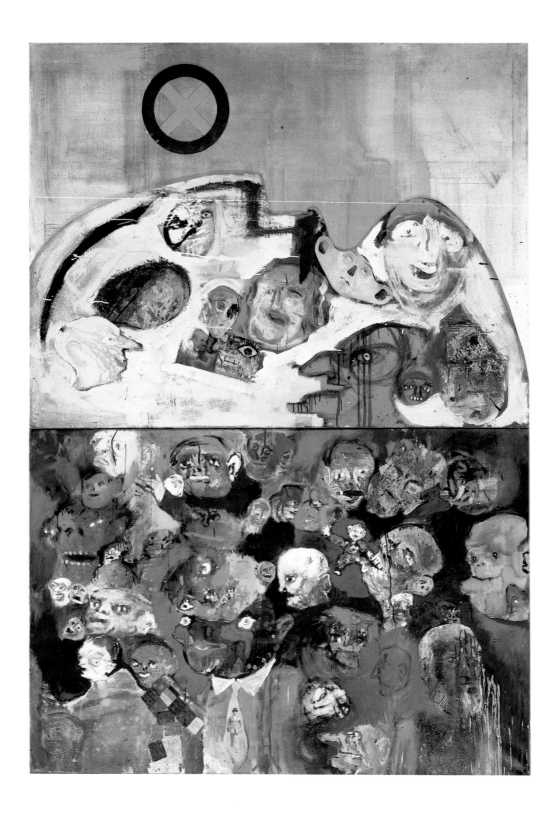

Rómulo Macció

10 *To Live: With a Pure Heart, 2 (No. 2 vivir: A corazón limpio).* **1963**
Enamel on canvas (lozenge), 96 x 97 in. (245.1 x 247 cm.)
64.1695

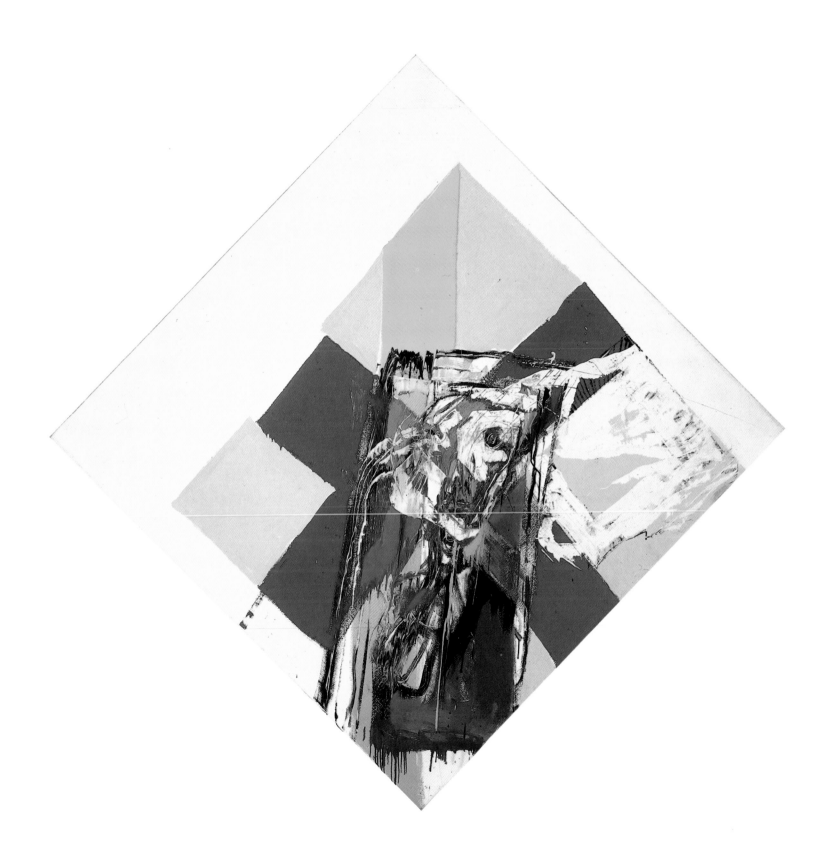

Jorge de la Vega

11 *Anamorphic Conflict No. 1 (The Measurement) (Conflicto* **1964**
 anamórfico no. 1 [la medida]).
 Oil and collage on canvas, 63¾ x 76¾ in. (161.9 x 194.8 cm.)
 Purchased with funds contributed by Fundación Neumann, Caracas,
 Venezuela
 66.1829

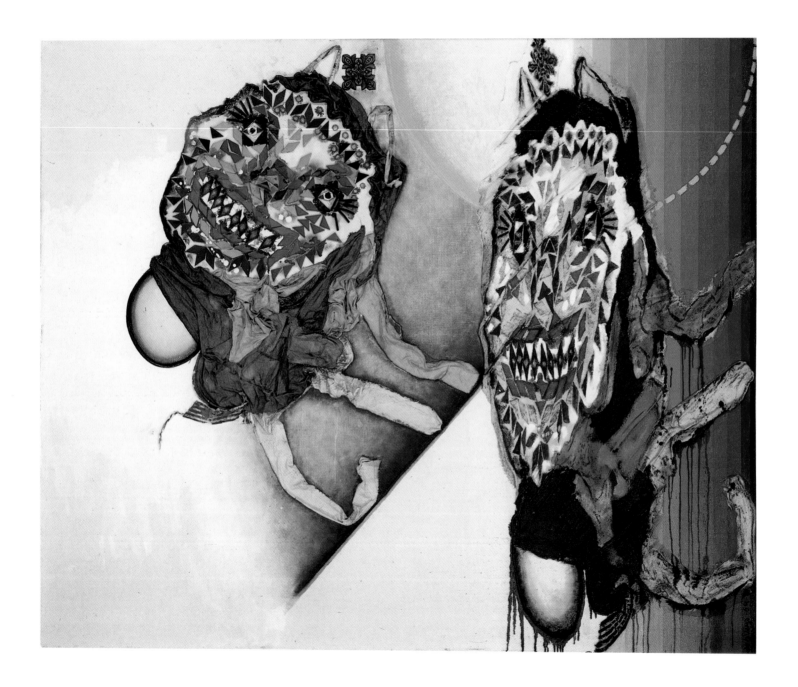

Ernesto Deira

12 *Turning to Thought "A" (No. 3) (En torno al pensamiento "A"* **1964**
[no. tres]).
Oil and enamel on canvas, 2 panels, each 76⅞ x 64 in. (195.3 x 162.5
cm.); total 76⅞ x 128 in. (195.3 x 325 cm.)
Purchased with funds contributed by Fundación Neumann, Caracas,
Venezuela
66.1817.a, .b

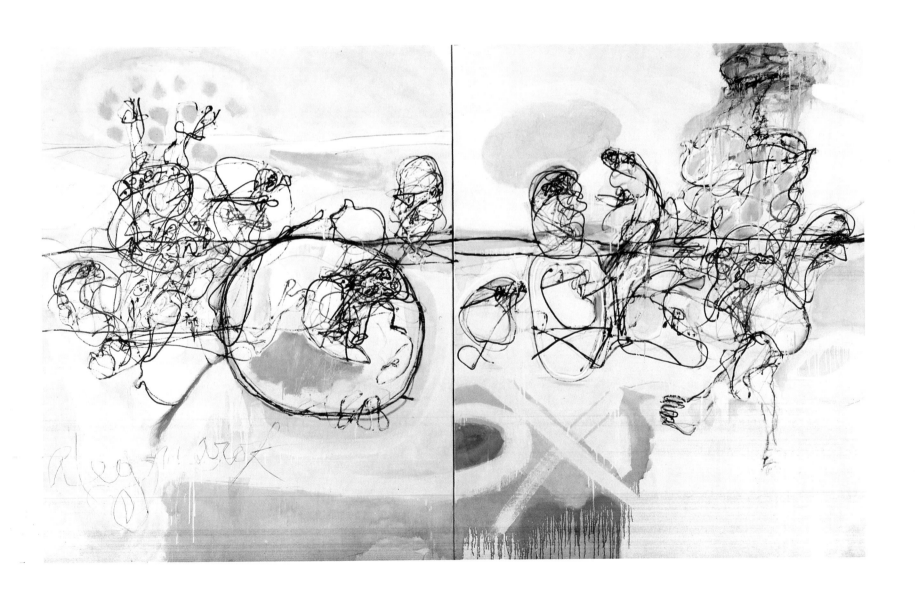

Fernando de Szyszlo

13 *Huanacauri II.* **1964**
 Encaustic on canvas, 62⅜ x 51 in. (158.4 x 129.5 cm.)
 Purchased with funds contributed by Fundación Neumann, Caracas,
 Venezuela
 66.1827

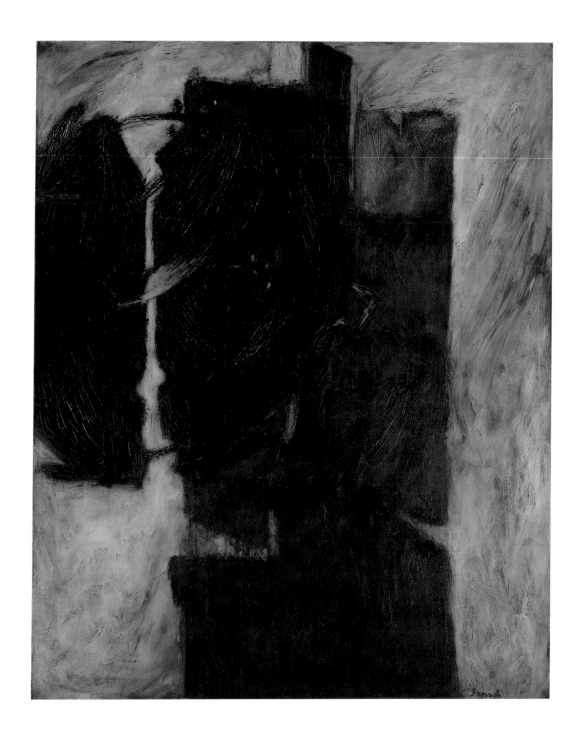

Ricardo Yrarrazaval

14 *Face (Rostro).* 1964
Oil on canvas, 58⅞ x 39½ in. (150 x 103 cm.)
Purchased with funds contributed by Fundación Neumann, Caracas,
Venezuela
66.1830

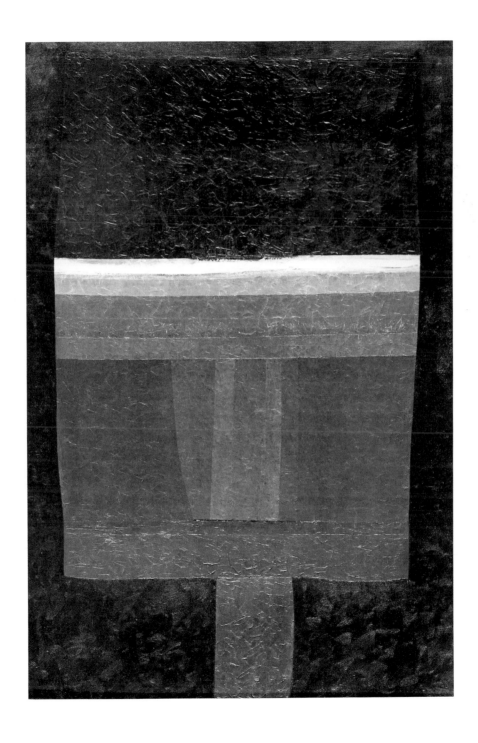

Armando Morales

15 *Landscape (Paisaje).* **1964**
 Oil and collage on canvas, 65 x 48¼ in. (165 x 122.2 cm.)
 Gift, Ramon Osuna III, by exchange
 68.1869

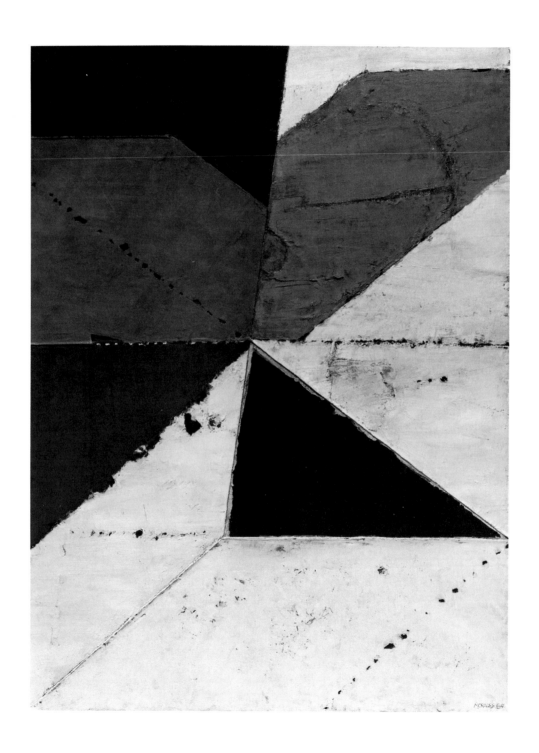

Rogelio Polesello

16 *Side A (Lado A).* 1965
 Oil on canvas, 102⅜ x 76¾ in. (260 x 195 cm.)
 Purchased with funds contributed by Fundación Neumann, Caracas,
 Venezuela
 66.1824

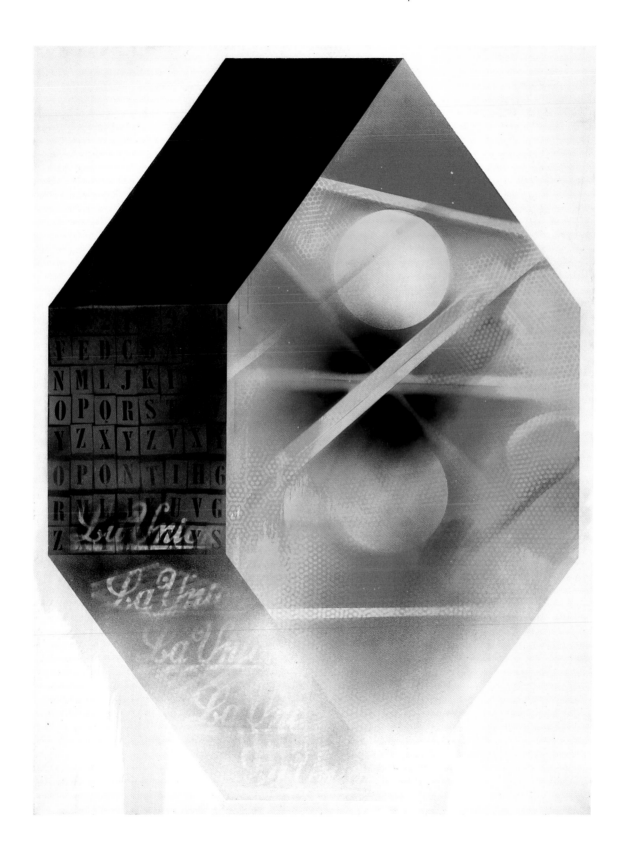

Alejandro Obregón

17 *The Baroque Garden (Jardin barroco).* **1965**
 Oil on canvas, 67⅝ x 79 in. (171.8 x 200.7 cm.)
 Purchased with funds contributed by Fundación Neumann, Caracas,
 Venezuela
 67.1843

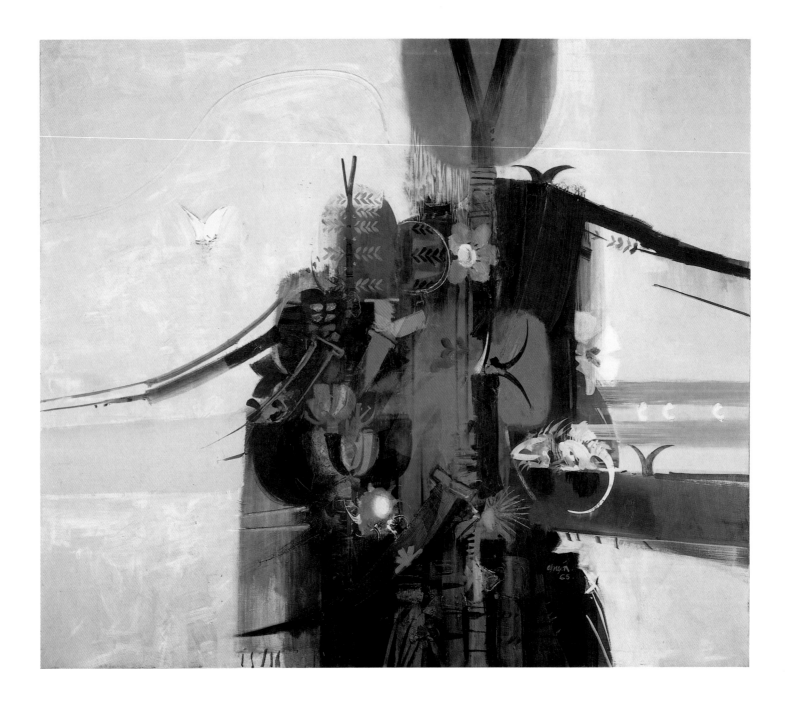

Jacobo Borges

18 *Something Has Broken (Algo se ha roto).* **1965**
 Oil on canvas, 58⅞ x 58⅞ in. (149.4 x 149.4 cm.)
 Gift, Mr. and Mrs. Cedric H. Marks
 71.1956

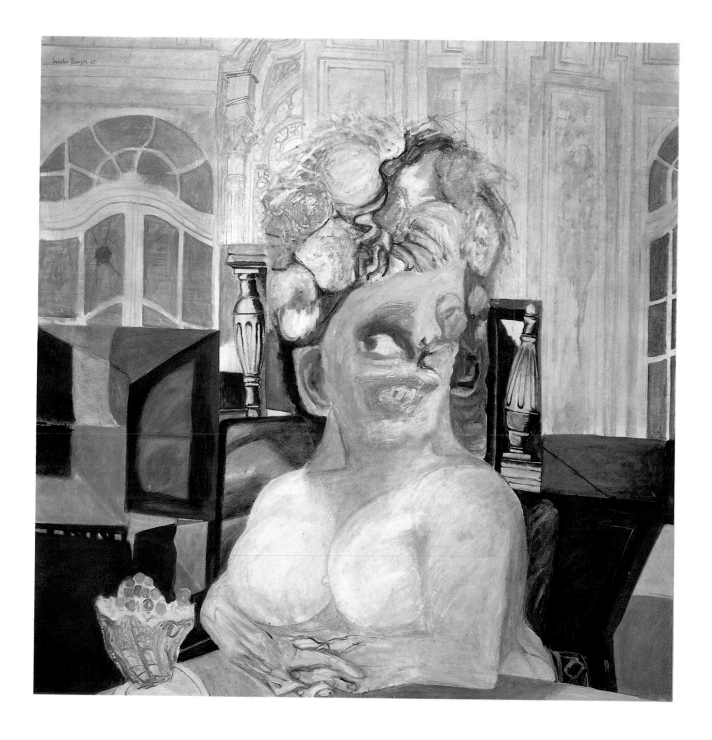

José Luis Cuevas

19 *The Printmaker Désandré Working on a Self-Portrait* **1965**
 (El grabador Désandré trabajando en un autoretrato).
 Ink and watercolor on paper, 18¼ x 22¾ in. (46.2 x 57.8 cm.)
 65.1774; SRGM hb. 184

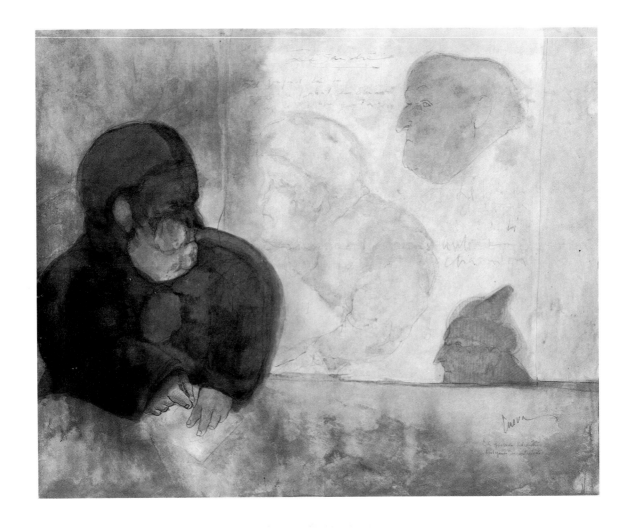

Jesús Rafael Soto

20 *Vibration (Vibración).* **1965**
 Metal and wood, 62½ x 42¼ x 5¾ in. (158.4 x 107.3 x 14.6 cm.)
 Gift, Eve Clendenin, New York
 67.1855

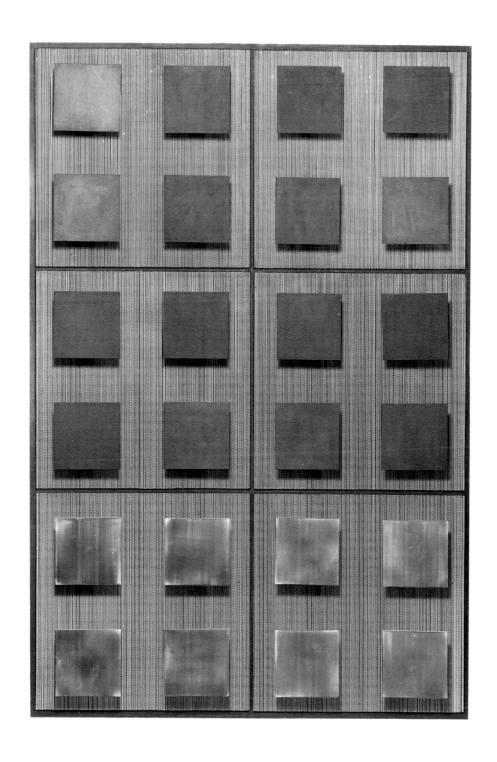

José Antonio Fernández-Muro

21 *Tangential Red.* **1966**
 Latex and embossed foil on canvas, 60 x 48 in. (152.2 x 122 cm.)
 Purchased with funds contributed by Fundación Neumann, Caracas,
 Venezuela
 66.1819

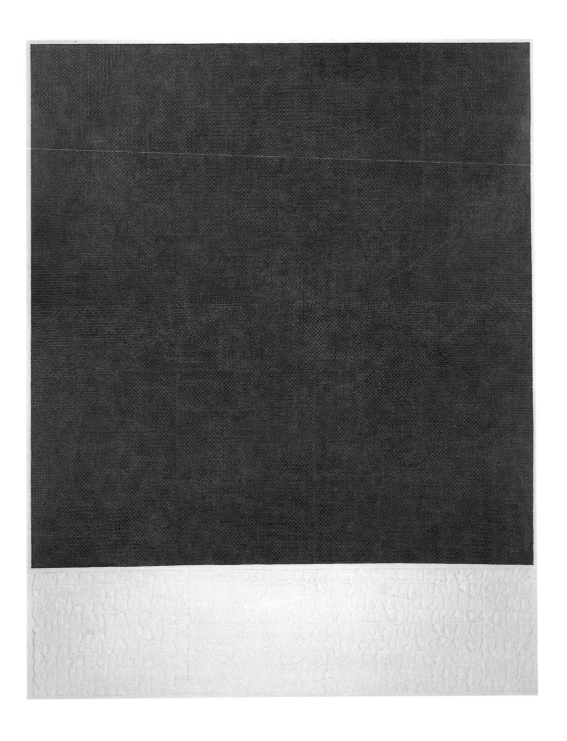

Miguel Angel Vidal

22 *First Vision (Vision primera).* **1967**
 Oil on canvas, 43¼ x 31½ in. (109.8 x 80 cm.)
 Purchased with funds contributed by Fundación Neumann, Caracas,
 Venezuela
 68.1867

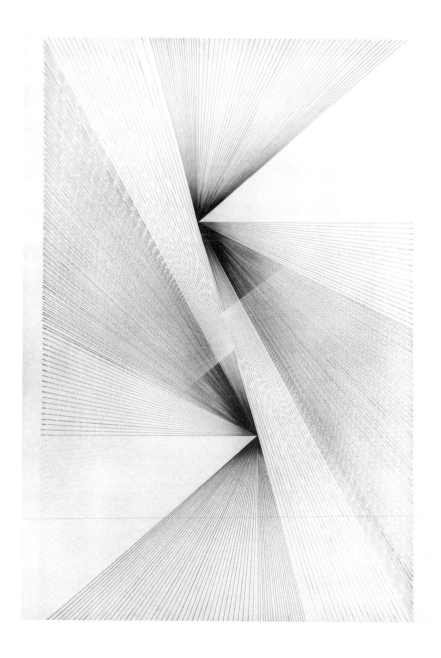

Eduardo MacEntyre

23 *In Red (En rojo).* 1967
 Oil on canvas, 39⅜ x 39⅜ in. (100 x 100 cm.)
 Purchased with funds contributed by Fundación Neumann, Caracas,
 Venezuela
 68.1868

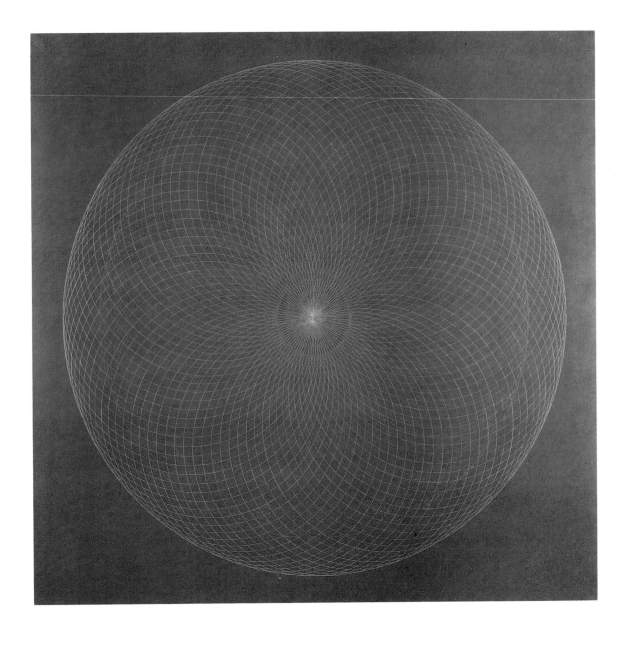

Antonio Segui

24 *Serrano Landscape (Paisaje Serrano).* **1969**
 Oil on canvas, 76¾ x 76¾ in. (194.9 x 194.9 cm.)
 Gift, Mr. and Mrs. Charles Goldsmith
 77.2296

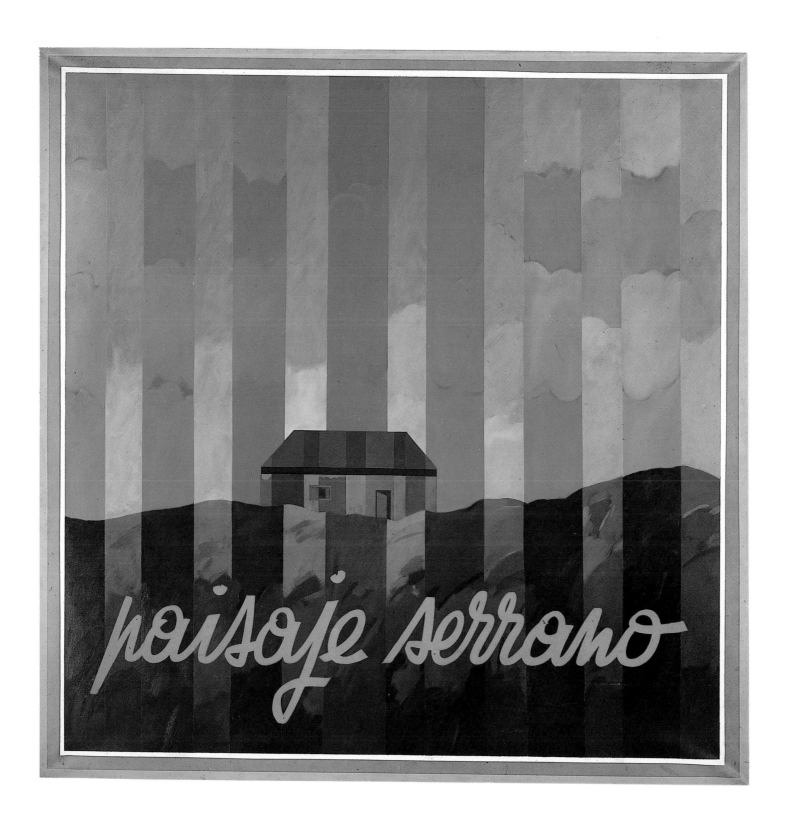

Maria Luisa Pacheco

25 *Anamorphosis.* **1971**
 Mixed media on canvas, 48¼ x 56 in. (122.5 x 142.2 cm.)
 71.1964

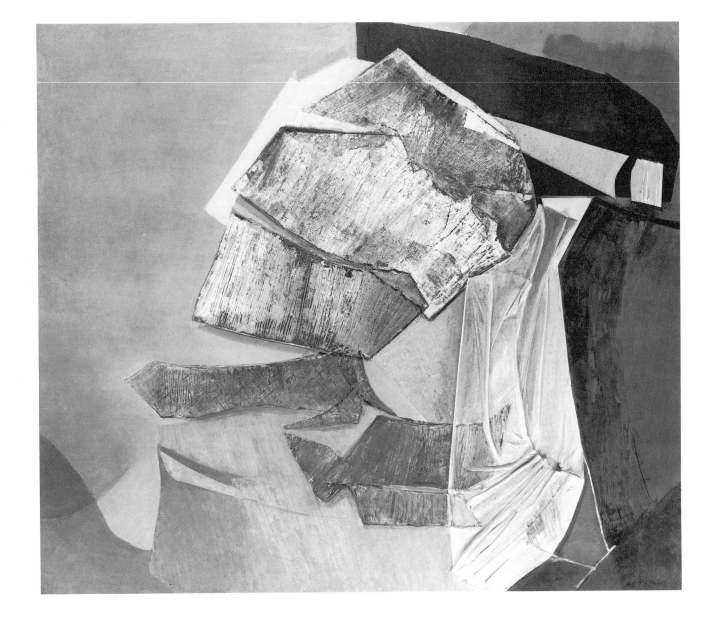

Marcelo Bonevardi

26 *The Supreme Astrolabe.* October **1973**
 Mixed media, 70¼ x 87 in. (178.1 x 222.2 cm.)
 Gift, The Dorothy Beskind Foundation
 73.2057

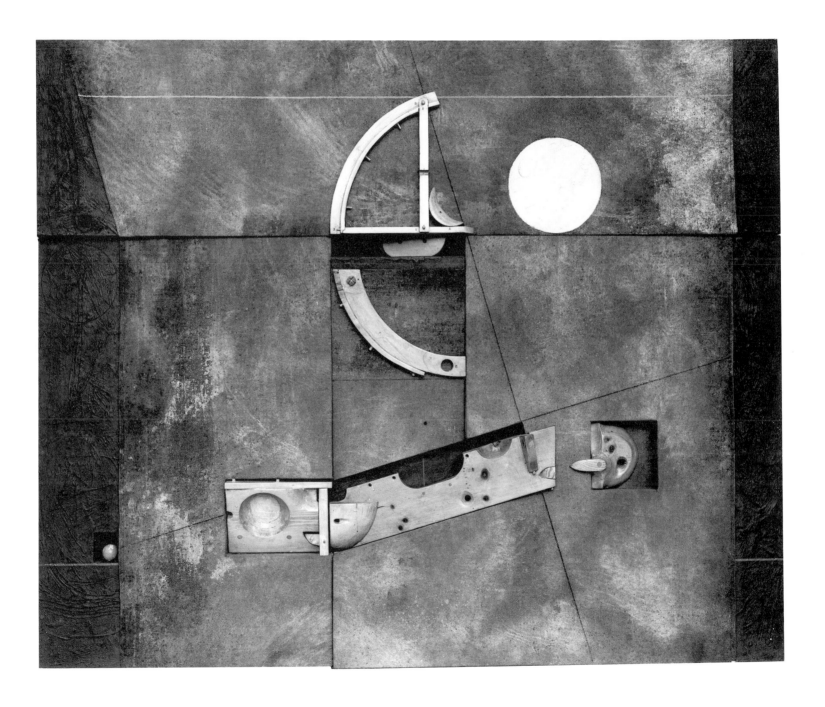

Enrique Castro-Cid

27 *Untitled.* 1974
 Oil, gouache, acrylic, pencil and ink on paper mounted on canvas,
 60 x 72¼ in. (152.3 x 183.5 cm.)
 Anonymous gift

 74.2093

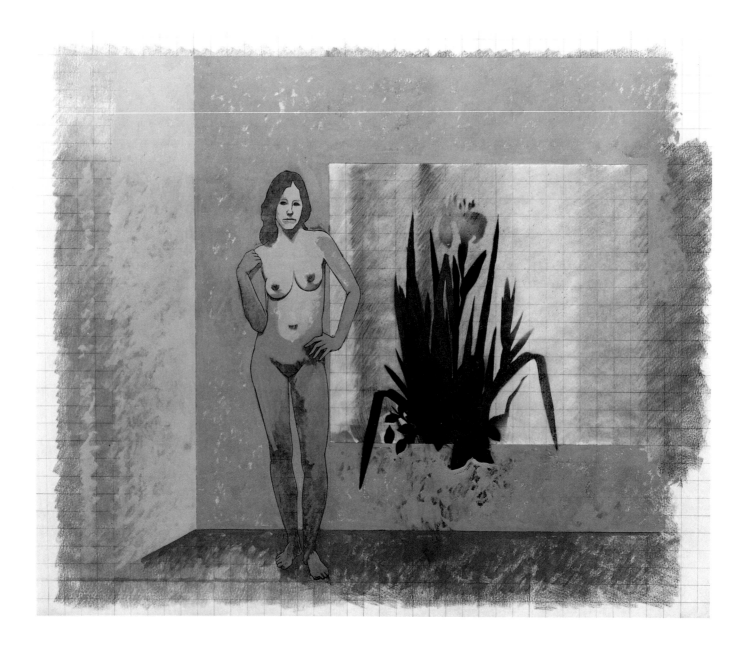

Carlos Cruz-Diez

28 *Physichromie No. 1059.* 1976
 Metal, acrylic and colored plastic strips, 39⅜ x 39⅜ in. (100 x 100 cm.)
 Gift, Mr. and Mrs. Peter O. Lawson-Johnston
 83.3048

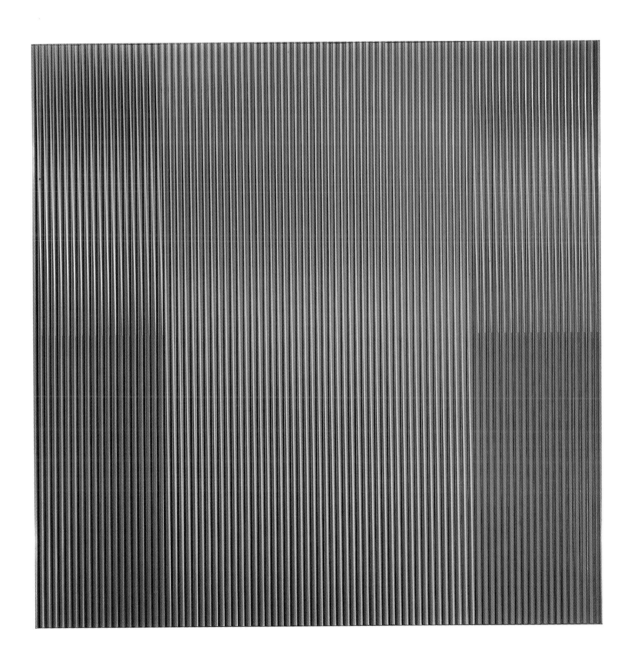

Rufino Tamayo

29 *Dancer (Danzante).* 1977
 Oil on canvas, 68½ x 54⅞ in. (174 x 139 cm.)
 77.2398

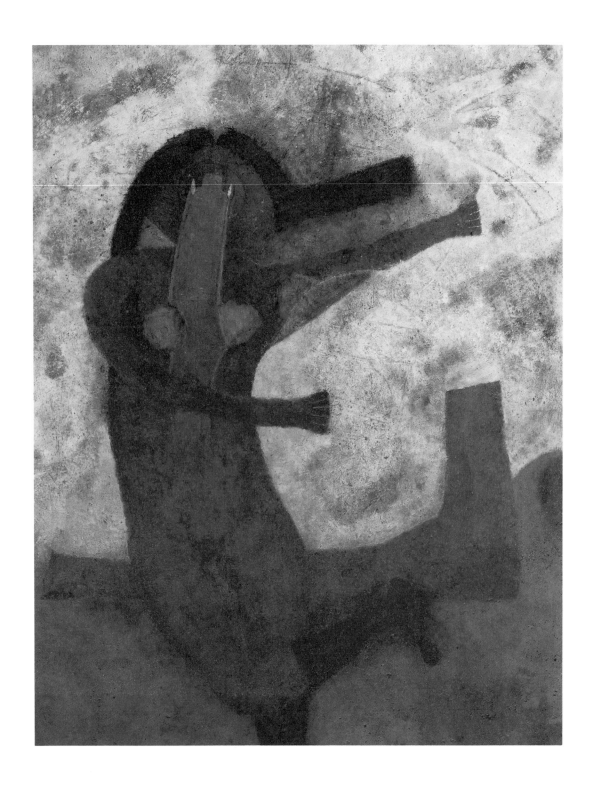

Cesar Paternosto

30 *Wari II.* 1985
 Oil on canvas, 72 x 62 in. (182.8 x 157.6 cm.)
 Gift, Dr. and Mrs. Natalio Schvartz
 86.3435

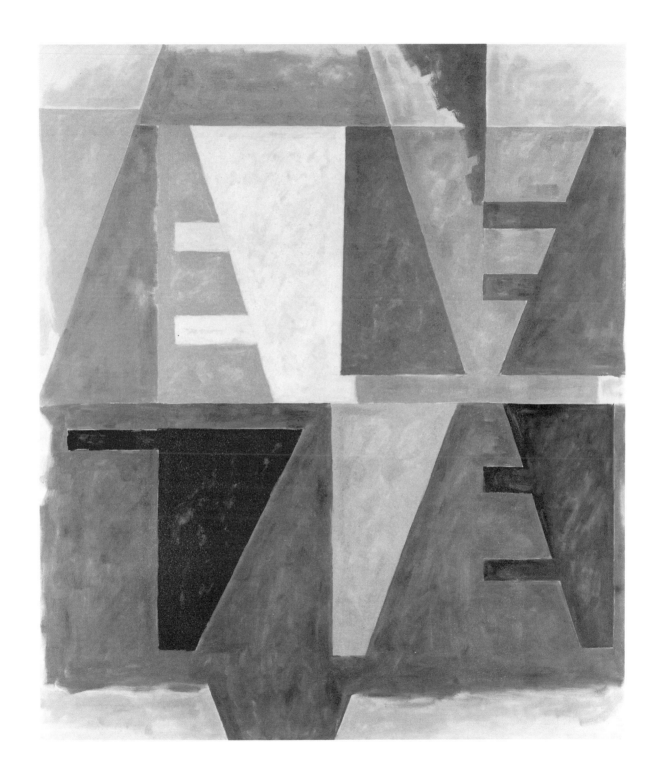

Oscar Maxera

31 *To New York.* 1985
 Acrylic on canvas, 35 x 23¹⁵⁄₁₆ in. (88.7 x 60.8 cm.)
 Gift of the artist
 85.3265

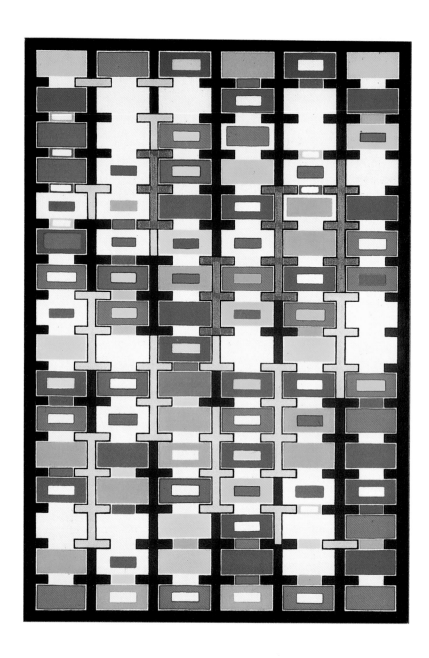

Jacobo Borges

32 *It's a Matter of Matter (Es materia).* 1987
 Oil on canvas, 70 x 56 in. (177.7 x 142.2 cm.)
 Purchased with funds contributed by Coral Pictures Corporation, Mr.
 Hernán Pérez Belisario, President
 87.3525

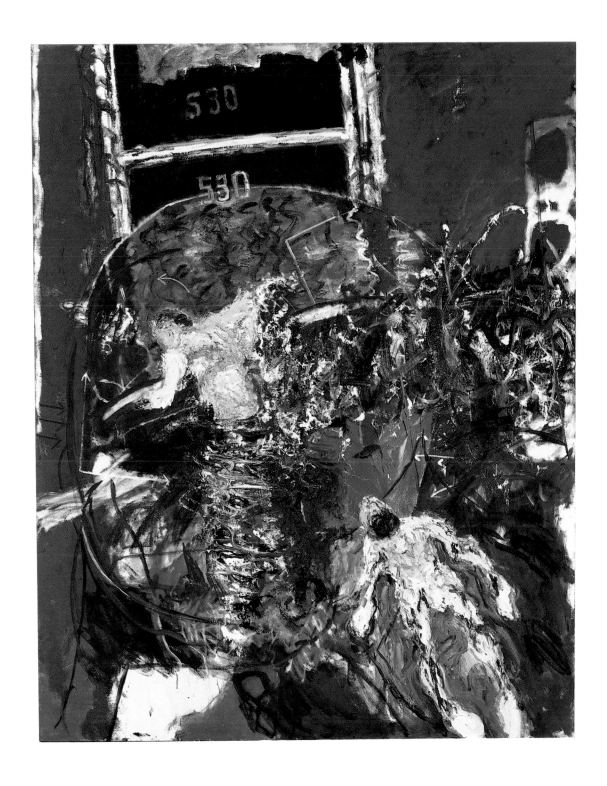

INDEX OF ARTISTS

Jackson Pollock

1 *The Moon Woman.* **1942**
 Oil on canvas, 69 x 43 ¹⁄₁₆ in. (175.2 x 109.3 cm.)
 Peggy Guggenheim Collection, Venice, The Solomon R. Guggenheim
 Foundation
 76.2553 PG 141; PGC cat. 142; PGC hb. 110

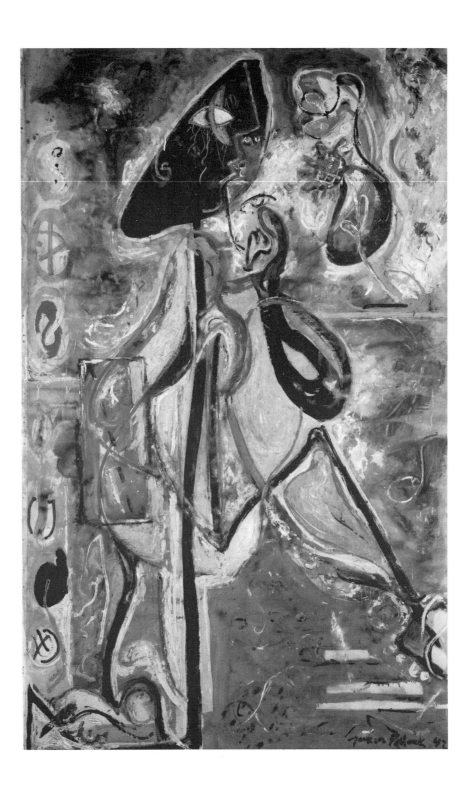

Jackson Pollock

2 *Two.* 1943–45
Oil on canvas, 76 x 43¼ in. (193 x 110 cm.)
Peggy Guggenheim Collection, Venice, The Solomon R. Guggenheim
Foundation
76.2553 PG 143; PGC cat. 144; PGC hb. 111

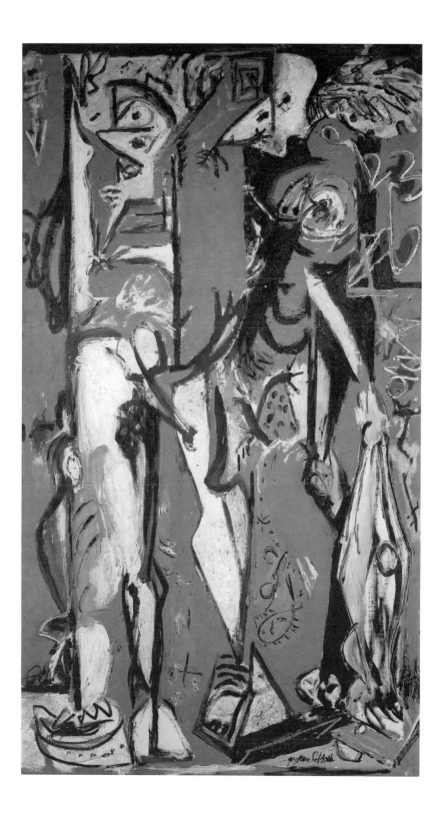

Clyfford Still

3 *Jamais.* May **1944**

Oil on canvas, 65 1/16 x 31 1/4 in. (165.2 x 82 cm.)

Peggy Guggenheim Collection, Venice, The Solomon R. Guggenheim
Foundation

76.2553 PG 153; PGC cat. 163; PGC hb. 122

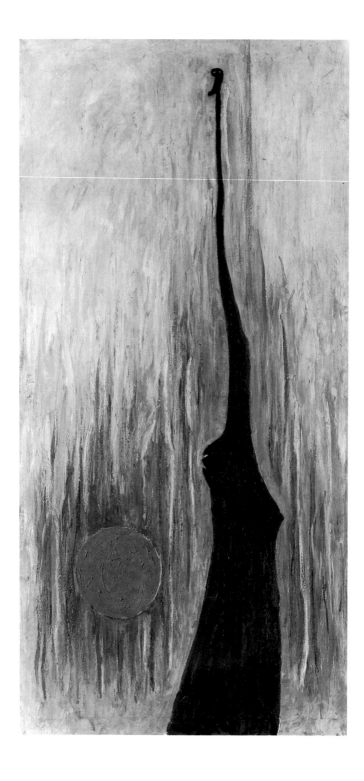

Arshile Gorky

4 *Untitled.* Summer **1944**

Oil on canvas, 65¾ x 70³⁄₁₆ in. (167 x 178.2 cm.)

Peggy Guggenheim Collection, Venice, The Solomon R. Guggenheim
Foundation

76.2553 PG 152; PGC cat. 73; PGC hb. 107

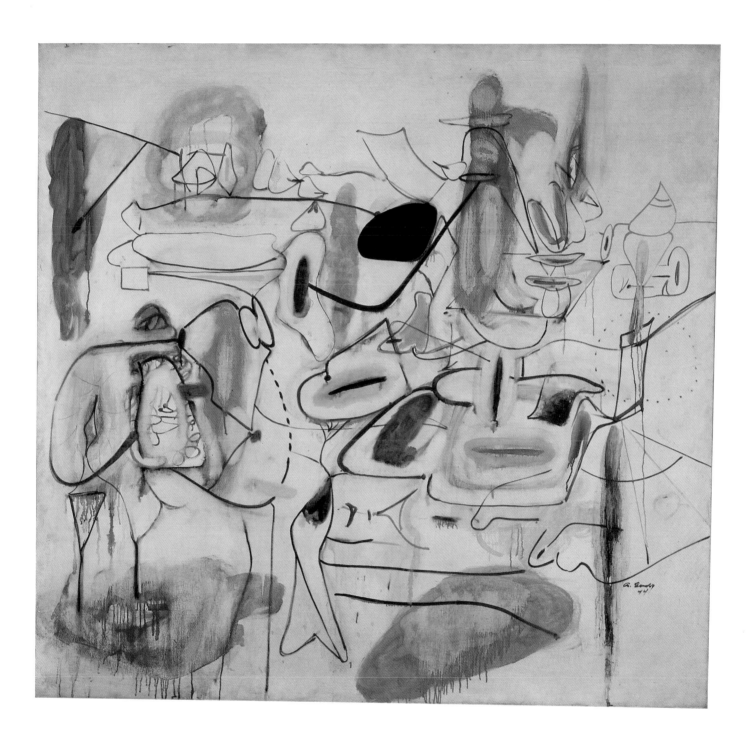

Jackson Pollock

5 *Circumcision.* January **1946**

Oil on canvas, 56¹/₁₆ x 66⅛ in. (142.3 x 168 cm.)

Peggy Guggenheim Collection, Venice, The Solomon R. Guggenheim
Foundation

76.2553 PG 145; PGC cat. 146; PGC hb. 113

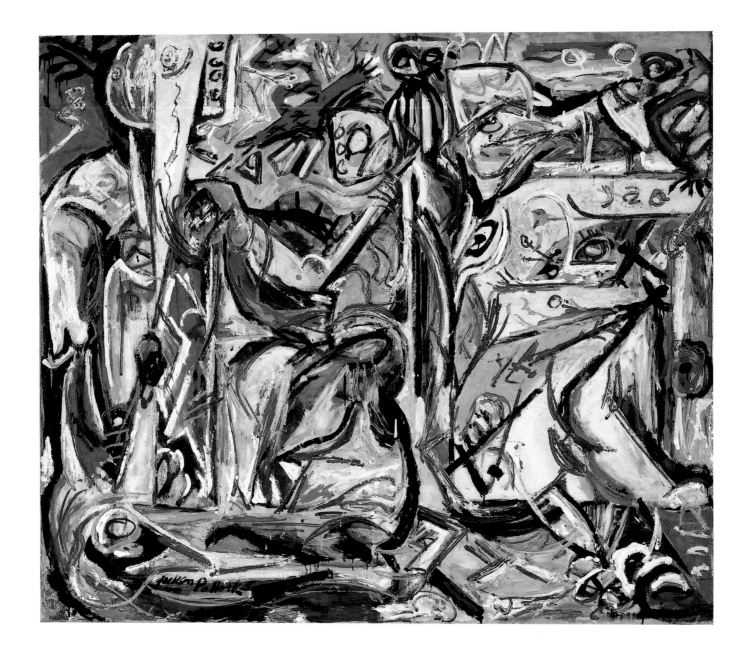

Jackson Pollock

6 *Enchanted Forest.* 1947
 Oil on canvas, 87⅛ x 45⅛ in. (221.3 x 114.6 cm.)
 Peggy Guggenheim Collection, Venice, The Solomon R. Guggenheim
 Foundation
 76.2553 PG 151; PGC cat. 151; PGC hb. 117

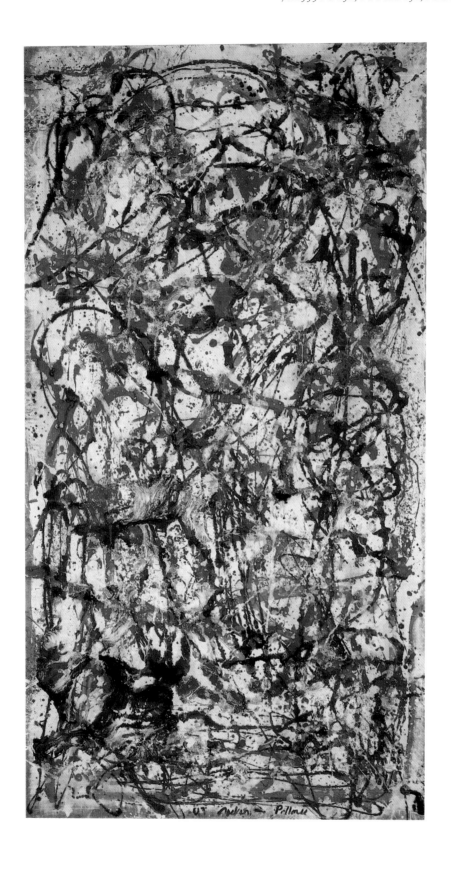

Theodoros Stamos

7 *What the Wind Does.* **1947–49**
 Oil on Masonite, 57⅝ x 44⅜ in. (146.3 x 112.7 cm.)
 By exchange
 86.3490

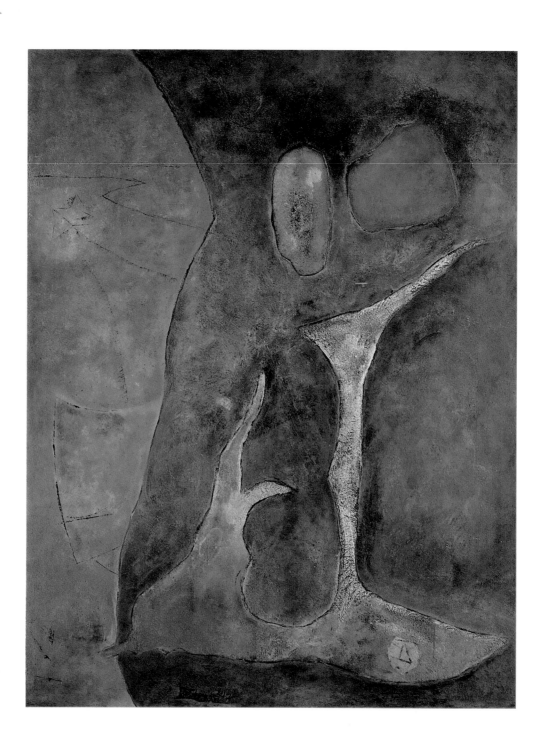

Mark Rothko

8 *Violet, Black, Orange, Yellow on White and Red.* **1949**
 Oil on canvas, 81½ x 66 in. (207 x 167.6 cm.)
 Purchased with funds contributed by Elaine and Werner Dannheisser and
 The Dannheisser Foundation
 78.2461; SRGM hb. 204

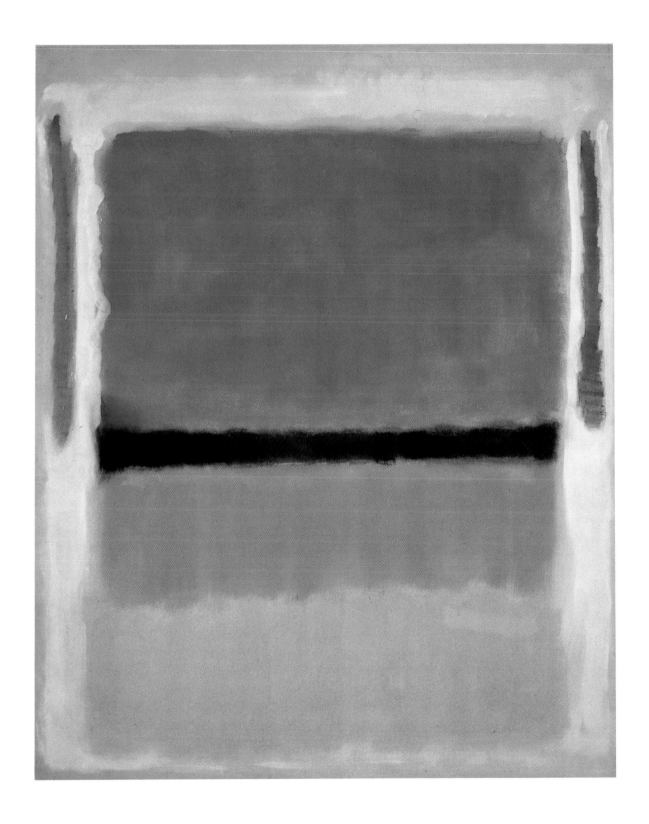

Ad Reinhardt

9 *Yellow Painting.* 1949
 Oil on canvas, 40 x 60 in. (101.6 x 152.4 cm.)
 Anonymous gift
 81.2763

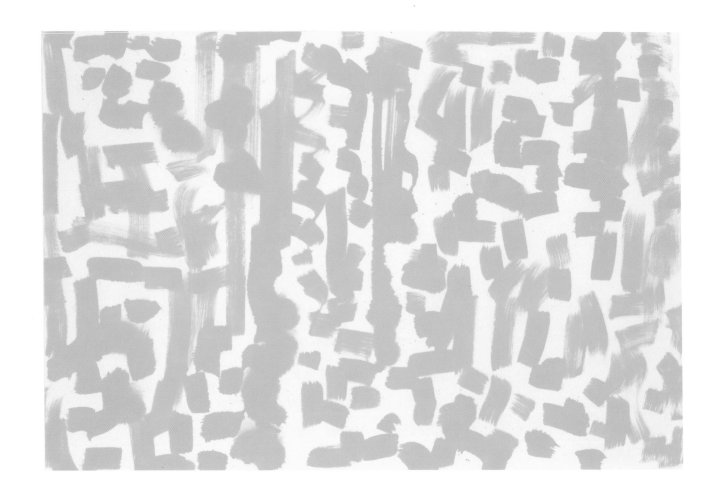

Ad Reinhardt

10 *Abstract Painting Blue.* 1952
 Oil on canvas, 50 x 20 in. (127 x 50.8 cm.)
 81.2762

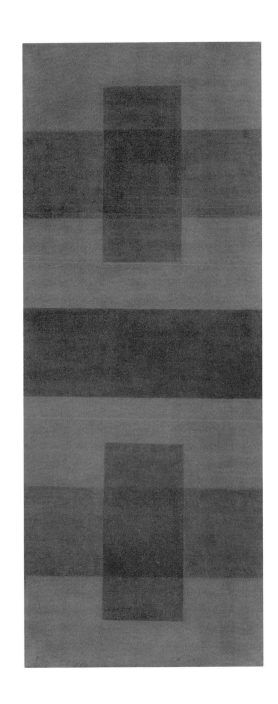

Franz Kline

11 *Painting No. 7.* 1952
 Oil on canvas, 57½ x 81¾ in. (146 x 207.6 cm.)
 54.1403; SRGM hb. 207

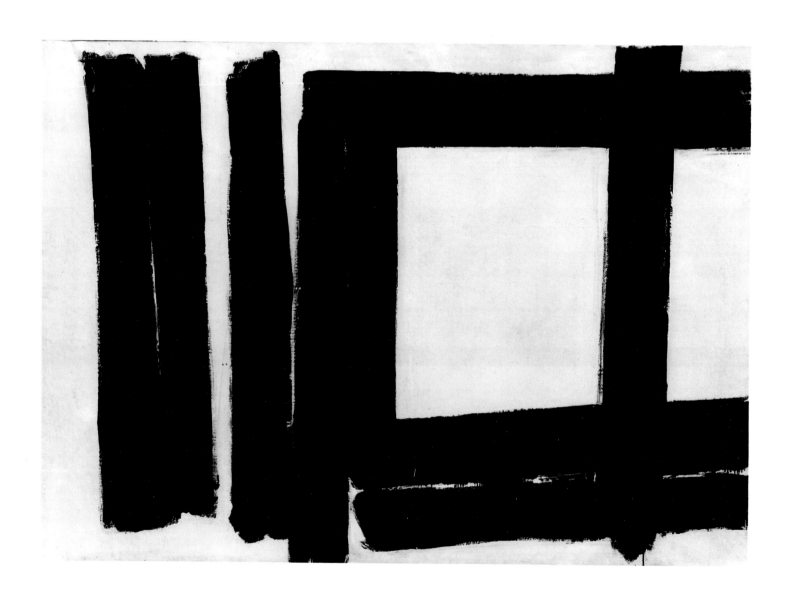

Jackson Pollock

12 *Ocean Greyness.* 1953
 Oil on canvas, 57¾ x 90⅛ in. (146.7 x 229 cm.)
 54.1408; SRGM hb. 201

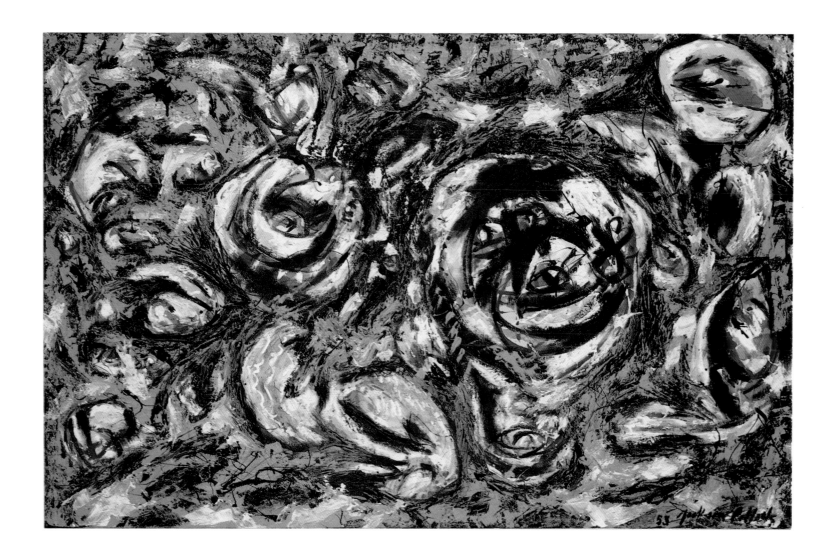

Robert Rauschenberg

13 *Red Painting.* 1953
 Oil, cloth and newsprint on canvas with wood, 79 x 33⅛ in. (200.6 x
 84.1 cm.)
 Gift, Walter K. Gutman
 63.1688; SRGM hb. 228

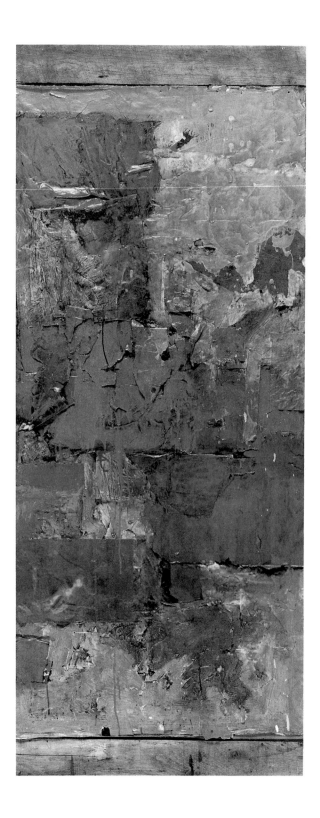

Willem de Kooning

14 *Composition.* 1955
Oil, enamel and charcoal on canvas, 79⅛ x 69⅛ in. (201 x 175.6 cm.)
55.1419; SRGM hb. 200

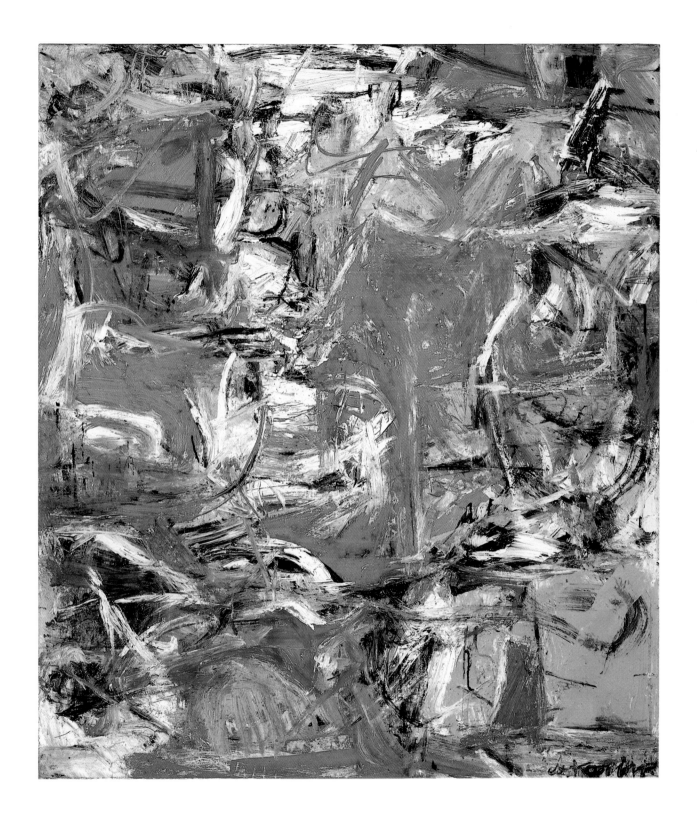

Jan Müller

15 *Jacob's Ladder.* January 1958
 Oil on canvas, 83½ x 115 in. (212.1 x 292.1 cm.)
 62.1609; SRGM hb. 223

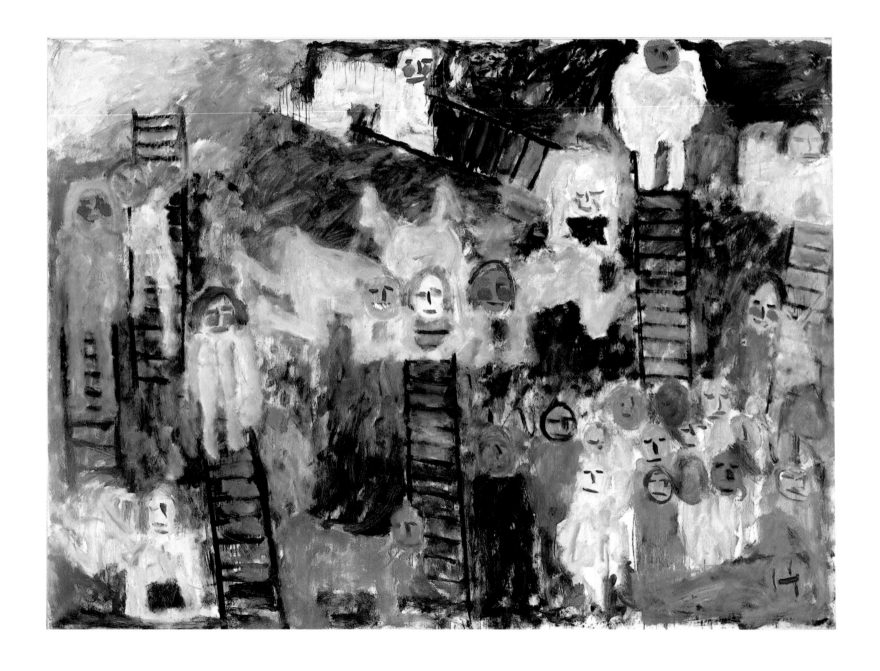

Sam Francis

16 *Shining Back.* 1958
 Oil on canvas, 79½ x 53 in. (202 x 134.6 cm.)
 59.1560; SRGM hb. 220

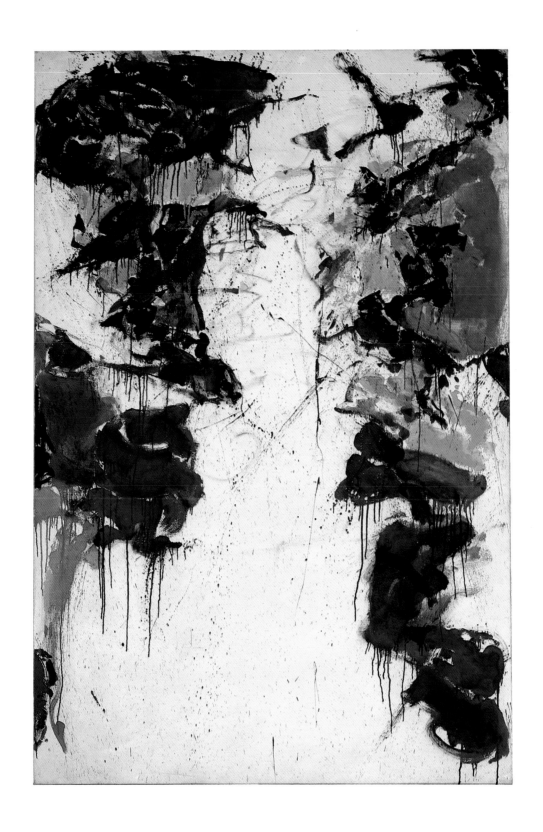

Josef Albers

17 *Homage to the Square: Apparition.* **1959**
 Oil on Masonite, 47½ x 47½ in. (121.9 x 121.9 cm.)
 61.1590; SRGM hb. 193

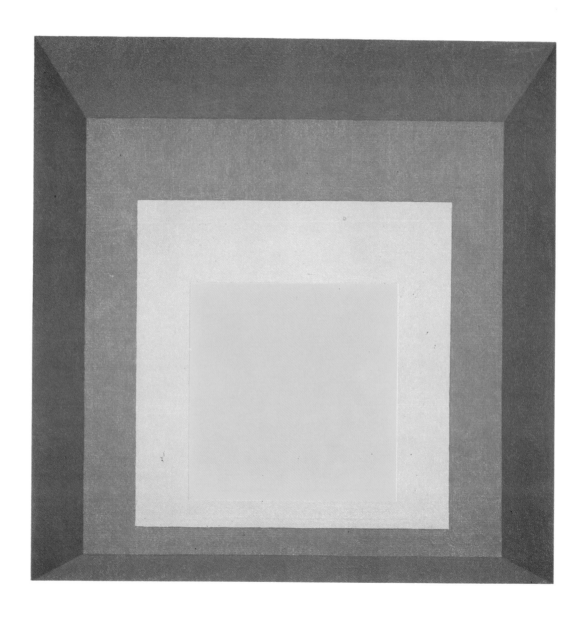

Morris Louis

18 *Saraband.* 1959
Acrylic resin on canvas, 101⅛ x 149 in. (257 x 378.5 cm.)
64.1685; SRGM hb. 237

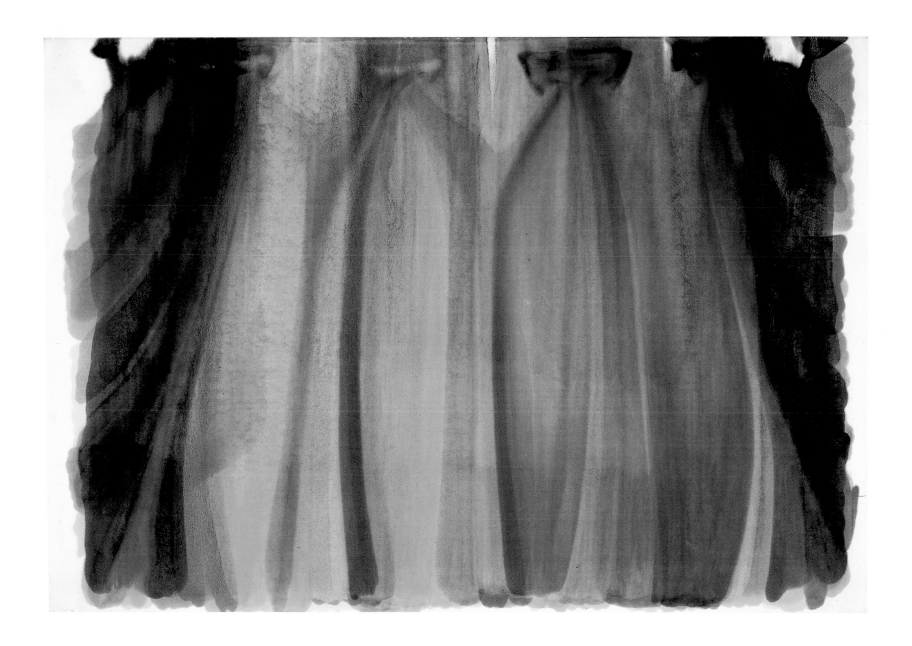

Jack Tworkov

19 *Red Lode.* 1959–60
 Oil on canvas, 67⅞ x 61 1/16 in. (172.2 x 155.1 cm.)
 Gift of the artist
 82.2913

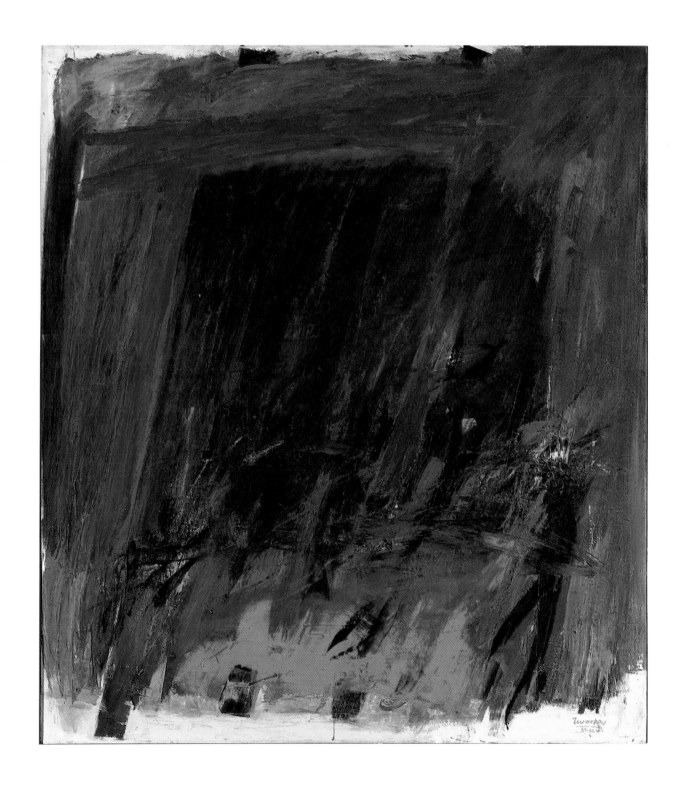

Hans Hofmann

20 *The Gate.* 1959–60
 Oil on canvas, 75⅛ x 48½ in. (190.7 x 123.2 cm.)
 62.1620; SRGM hb. 194

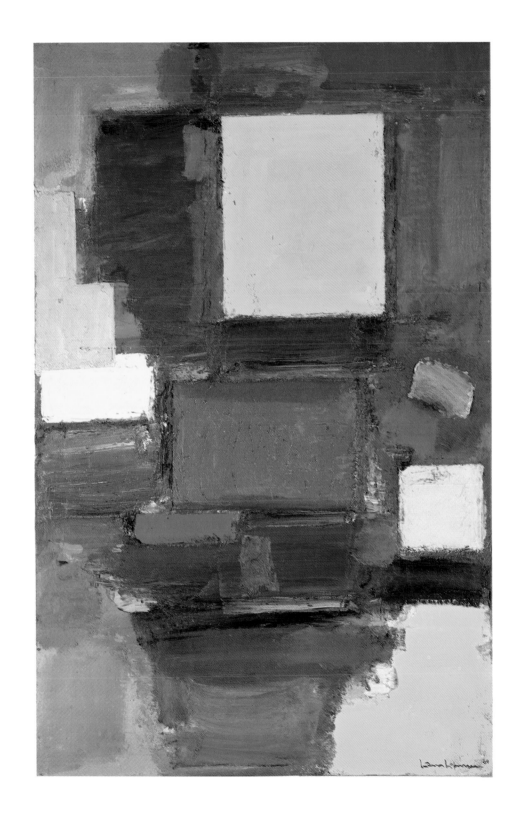

Al Held

21 *Untitled Y.* **1960**
 Acrylic on canvas, 72 x 48½ in. (183 x 122.5 cm.)
 Purchased with funds contributed by Robert and Adrian Mnuchin
 81.2761

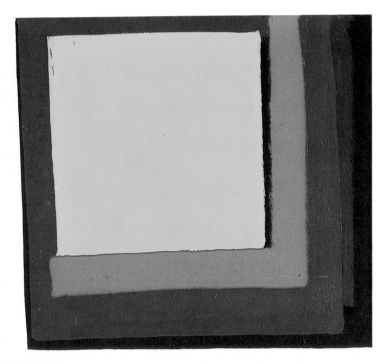

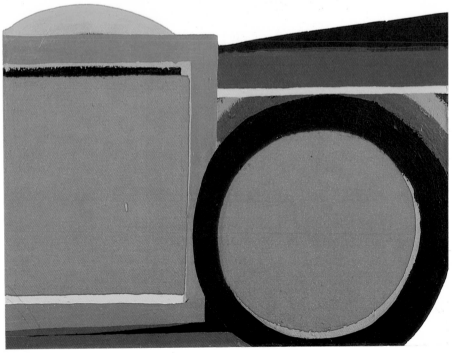

William Baziotes

22 *Aquatic.* 1961
 Oil on canvas, 66 x 78⅛ in. (167.6 x 198.4 cm.)
 Collective anonymous gift
 63.1630; SRGM hb. 203

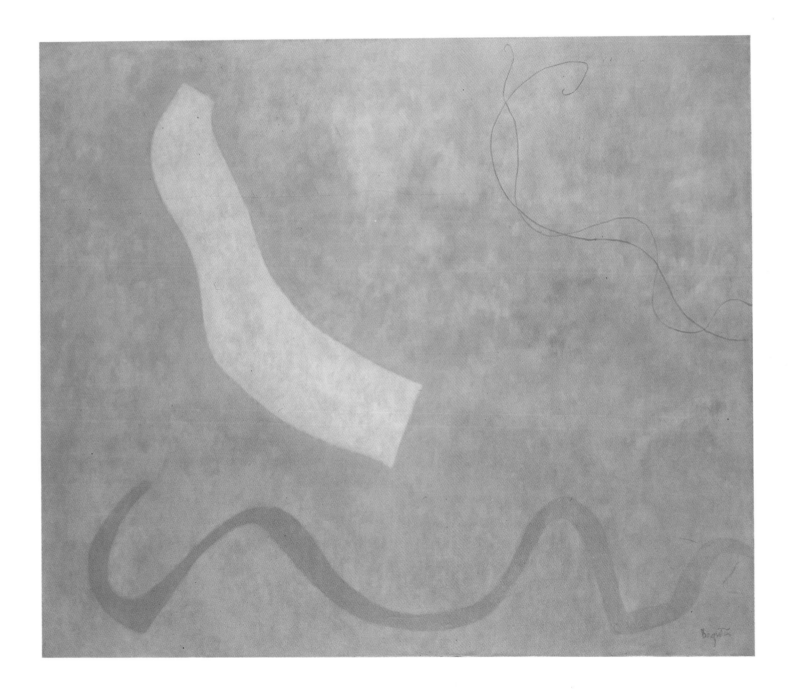

Adolph Gottlieb

23 *Mist.* 1961
 Oil on canvas, 72 x 48 in. (182.9 x 121.9 cm.)
 Gift, Susan Morse Hilles
 78.2401; SRGM hb. 206

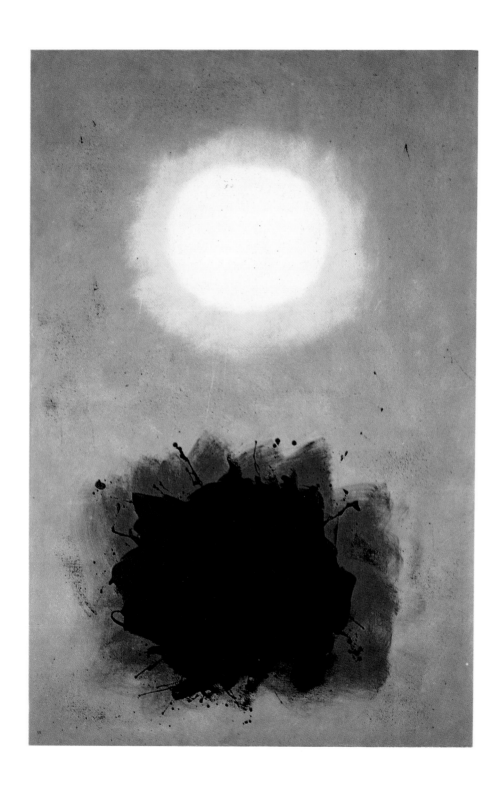

Philip Guston

24 *Duo.* 1961
 Oil on canvas, 72⅛ x 68 in. (183.1 x 172.6 cm.)
 64.1683; SRGM hb. 209

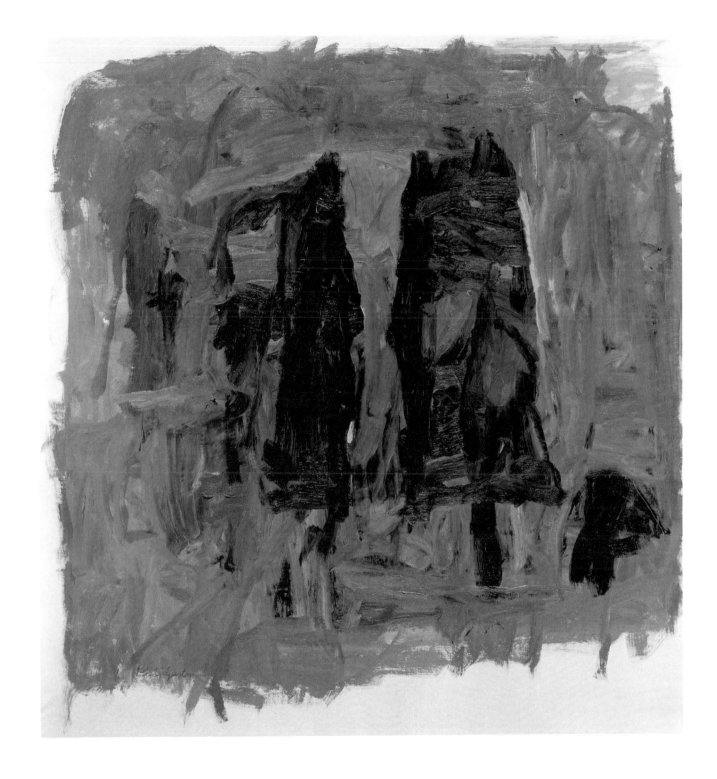

Jim Dine

25 *Pearls.* 1961
 Oil and collage on canvas, 70 x 60 in. (177.7 x 152.3 cm.)
 Gift, Leon A. Mnuchin
 63.1681; SRGM hb. 229

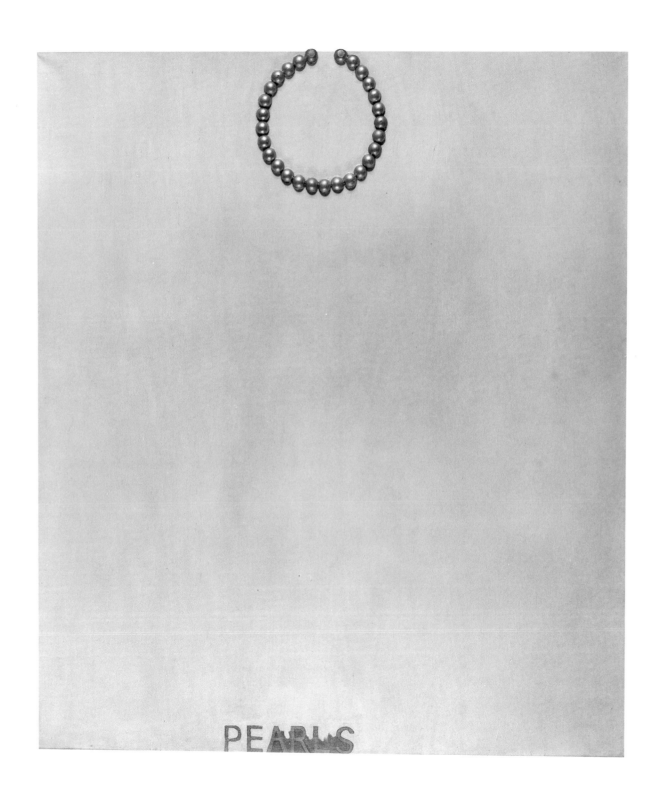

Morris Louis

26 *I-68.* 1962
 Acrylic resin on canvas, 83¾ x 42 in. (212.7 x 106.7 cm.)
 67.1846; SRGM hb. 238

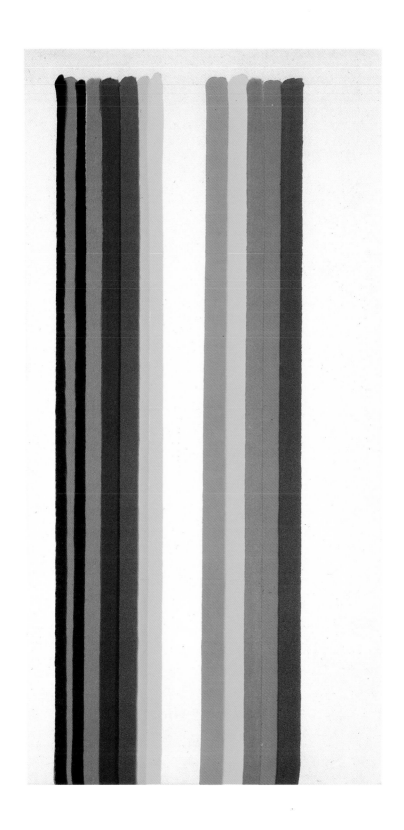

Mark Rothko

27 *Black, Orange on Maroon (#18).* **1963**
 Oil on canvas, 69⅛ x 64⅜ in. (175.6 x 163.5 cm.)
 Gift, The Mark Rothko Foundation, Inc.
 86.3421

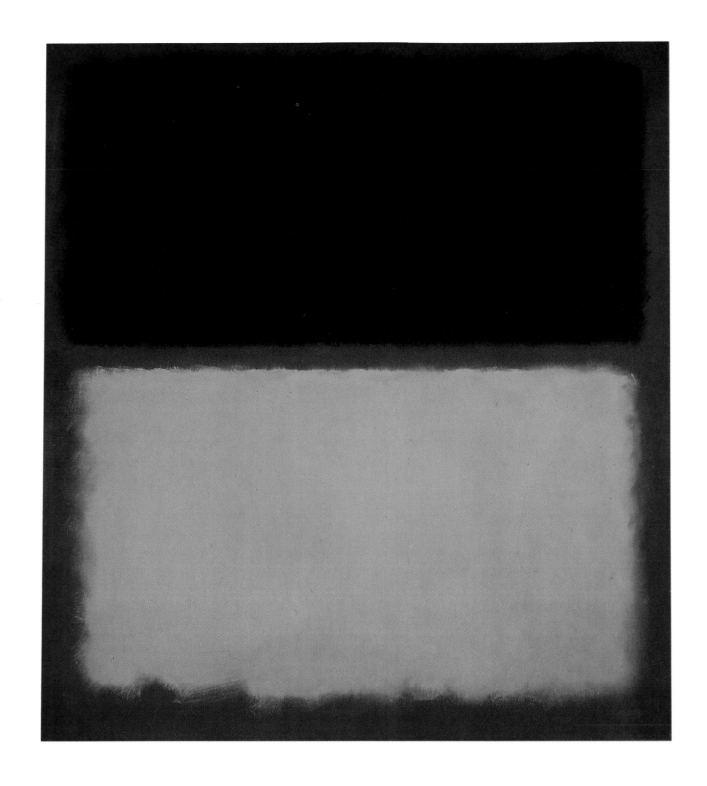

Helen Frankenthaler

28 *Canal.* 1963
 Acrylic on canvas, 81 x 57½ in. (205.7 x 146 cm.)
 Purchased with the aid of funds from the National Endowment for the
 Arts in Washington, D.C., a Federal Agency; matching gift, Evelyn Sharp
 76.2225; SRGM hb. 236

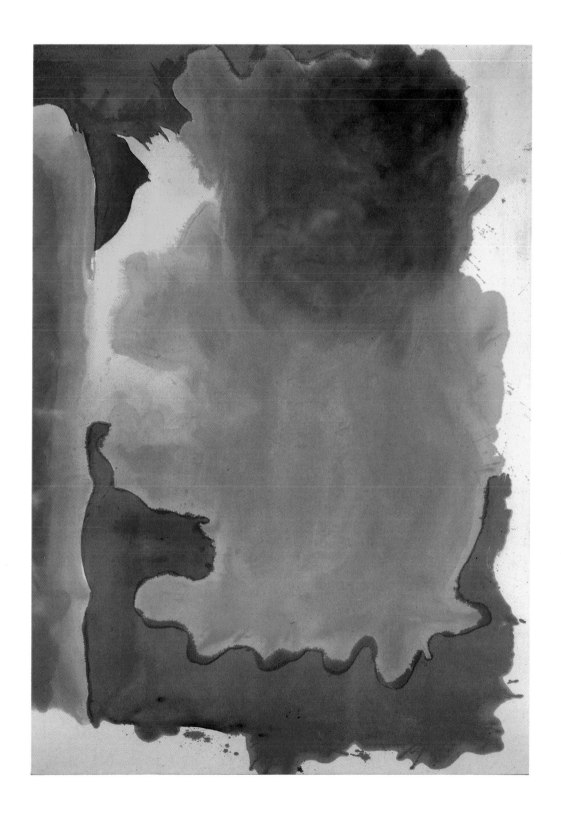

Robert Rauschenberg

29 *Untitled.* **1963**

Oil, silk screen, ink, metal and plastic on canvas, 82 x 48 in.
(208.3 x 121.9 cm.)

Purchased with funds contributed by Elaine and Werner Dannheisser and
The Dannheisser Foundation

82.2912

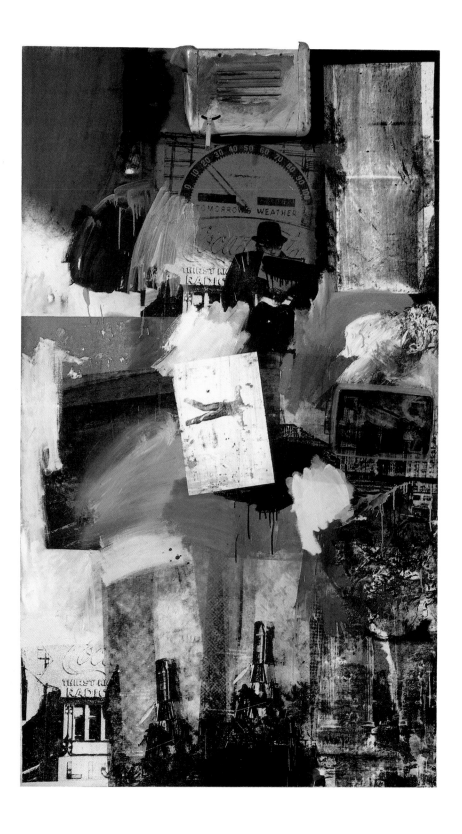

Andy Warhol

30 *Orange Disaster, No. 5.* 1963
 Acrylic and silk-screen enamel on canvas, 106 x 81½ in.
 (269.2 x 207 cm.)
 Gift, Harry N. Abrams Family Collection
 74.2118; SRGM hb. 230

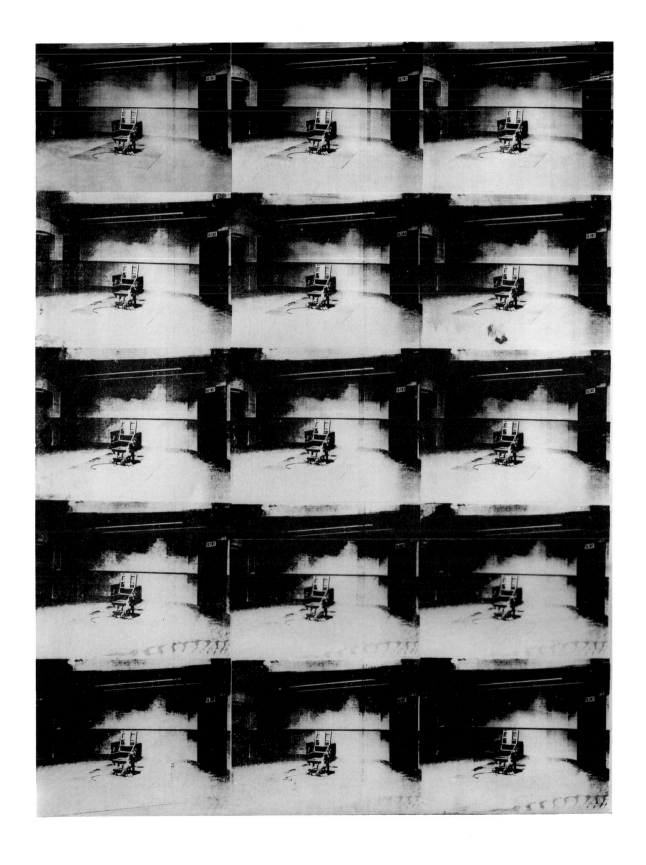

Larry Rivers

31 *Dutch Masters Presidents Relief.* **1964**
Oil and collage on canvas mounted in wood box, 97¾ x 69¾ x 14¼ in.
(248.3 x 176.8 x 36.2 cm.)
Gift, Stanley and Alice Bard
86.3485

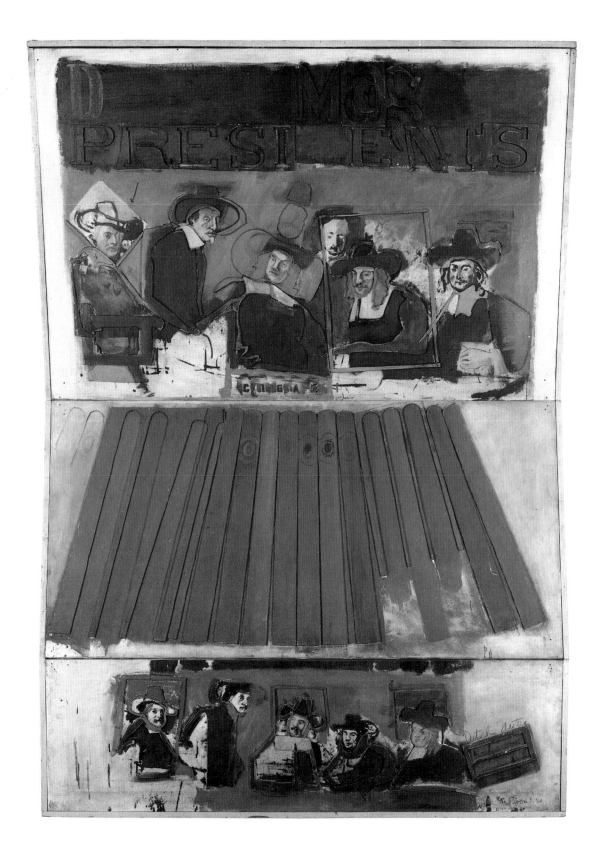

Alfred Jensen

32 *Uaxactun.* 1964
 Oil on canvas, 50¼ x 50¼ in. (127.7 x 127.7 cm.)
 72.2018; SRGM hb. 211

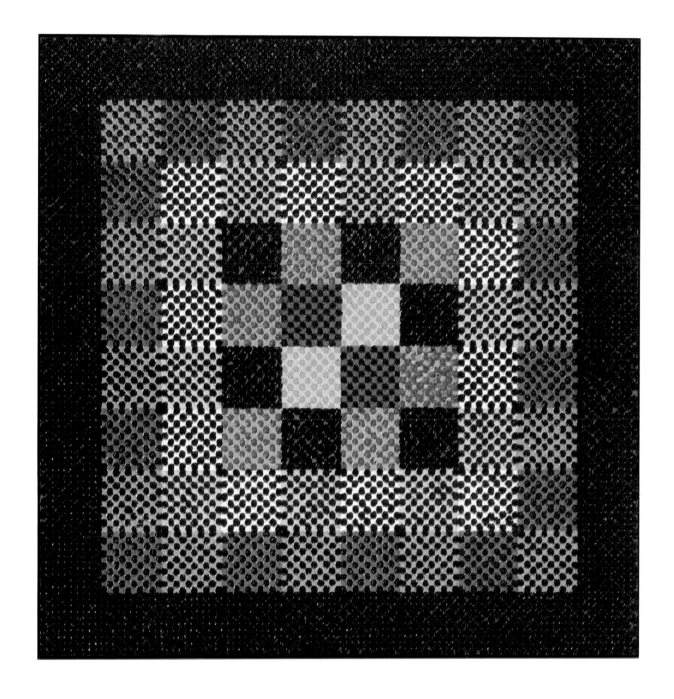

Kenneth Noland

33 *Trans Shift.* 1964
Acrylic on canvas, 100 x 113½ in. (254 x 288.3 cm.)
Purchased with funds contributed by Elaine and Werner Dannheisser and
The Dannheisser Foundation
81.2812

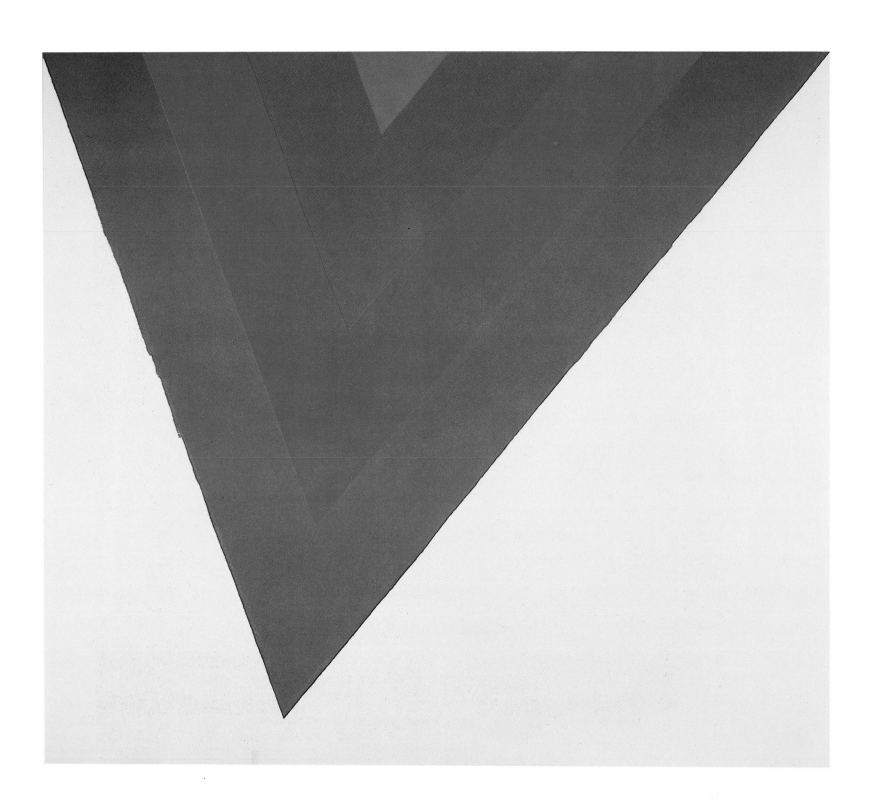

Jack Youngerman

34 *Long March II.* 1964
 Oil on canvas, 90 x 94⅞ in. (228.7 x 241 cm.)
 Gift, Paul Waldman
 78.2504

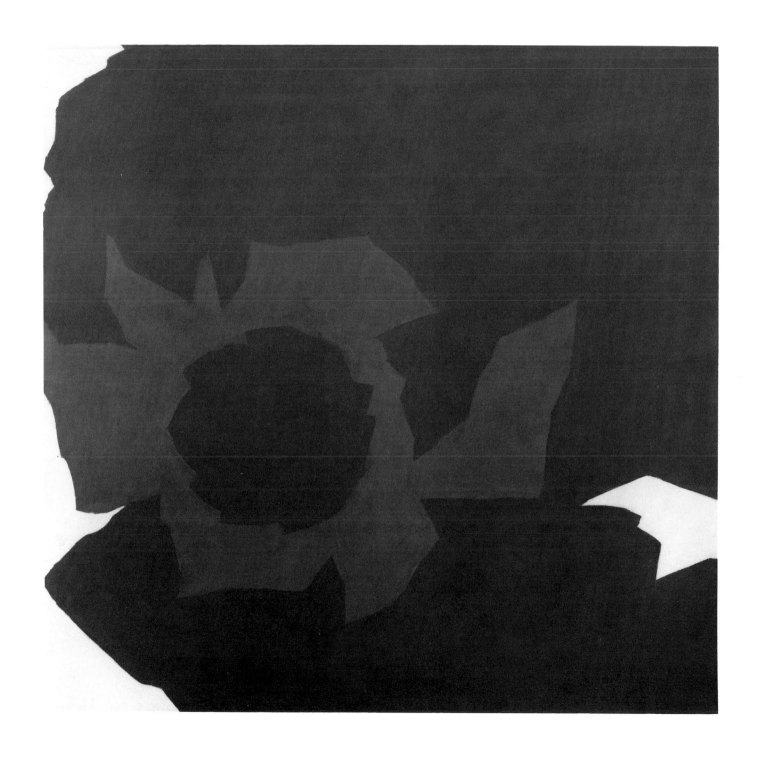

Paul Feeley

35 *Formal Haut.* 1965
 Acrylic on canvas, 60 x 60 in. (152.4 x 152.4 cm.)
 66.1832; SRGM hb. 235

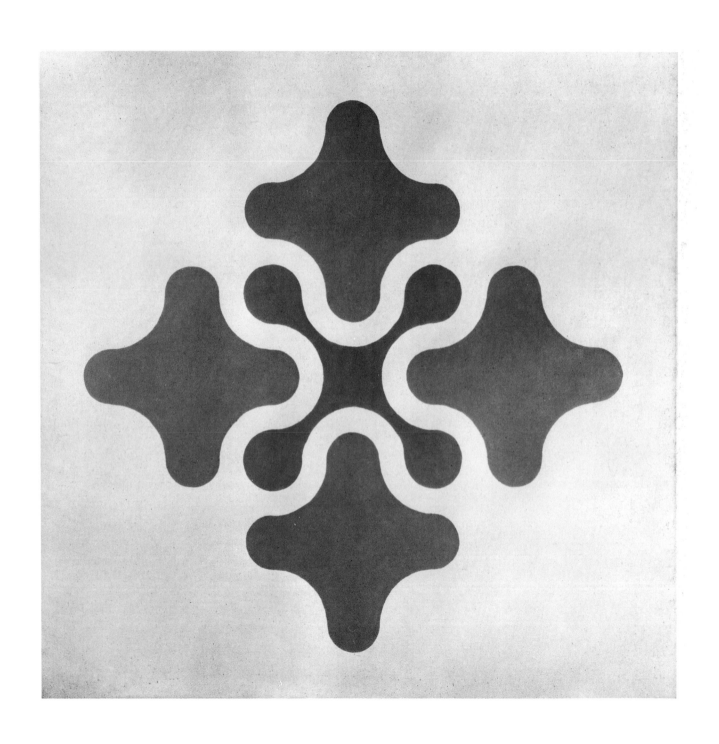

Ellsworth Kelly

36 *Blue, Green, Yellow, Orange, Red.* **1966**
Oil on canvas, 5 panels, each 60 x 48 in. (152.3 x 121.9 cm.); total
60 x 240 in. (52.4 x 609.6 cm.)
67.1833.a–.e; SRGM hb. 242

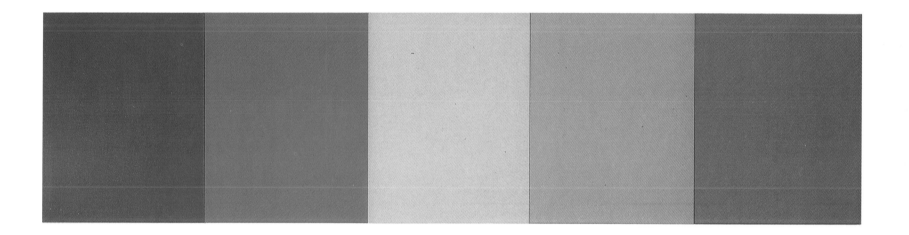

Robert Ryman

37 *Delta II.* **1966**
 Oil on cotton, 105 x 105 in. (266.7 x 266.7 cm.)

 Purchased with the aid of funds from the National Endowment for the
 Arts in Washington, D.C., a Federal Agency; partial gift, Mrs. Leo Simon

 72.2022

38 *Harran II.* 1967
 Polymer and fluorescent polymer paint on canvas, 120 x 240 in.
 (304.8 x 609.6 cm.)
 Gift, Mr. Irving Blum
 82.2976

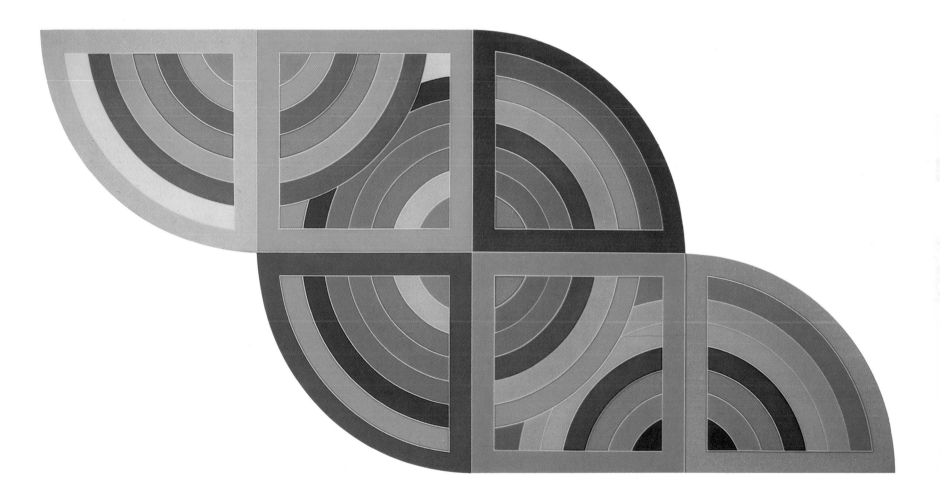

Roy Lichtenstein

39 *Preparedness.* **1968**
 Magna on canvas, 3 panels, each 120 x 72 in. (304.8 x 183 cm.); total
 120 x 216 in. (304.8 x 548.7 cm.)
 69.1885.a–.c; SRGM hb. 231

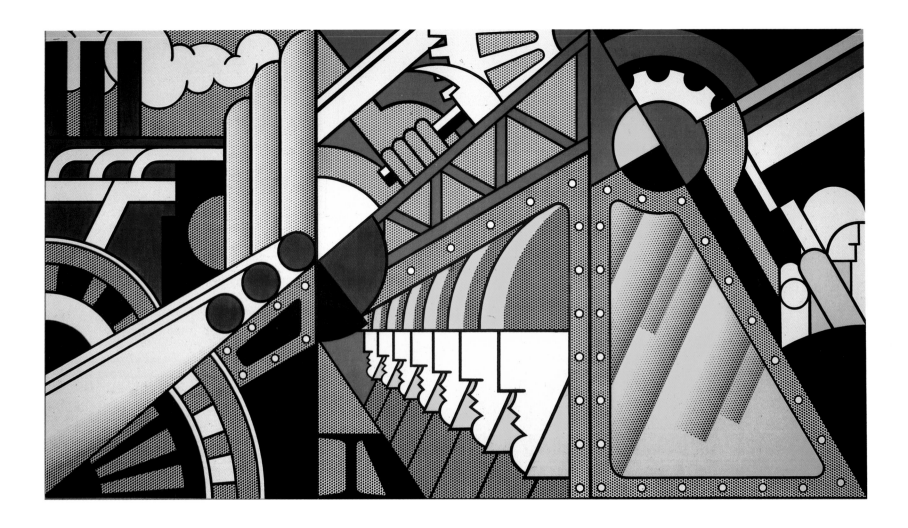

Neil Jenney

40 *Media and Man.* **1969**
 Acrylic on canvas in artist's wood frame, 59¾ x 58¾ in.
 (151.7 x 149.2 cm.)
 Purchased with funds contributed by the Denise and Andrew Saul
 Philanthropic Fund
 87.3512

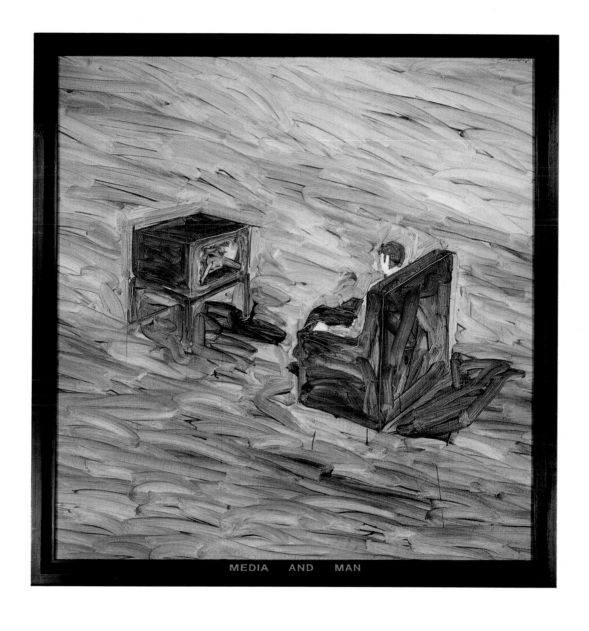

MEDIA AND MAN

Jules Olitski

41 *Lysander I.* 1970
 Acrylic on canvas, 96⅝ x 124¾ in. (245.5 x 317 cm.)
 Anonymous gift
 86.3484

Robert Motherwell

42 *Elegy to the Spanish Republic.* 1971
Acrylic and pencil on canvas, 82 x 114 in. (208 x 289.6 cm.)
Gift, Agnes Gund
84.3223

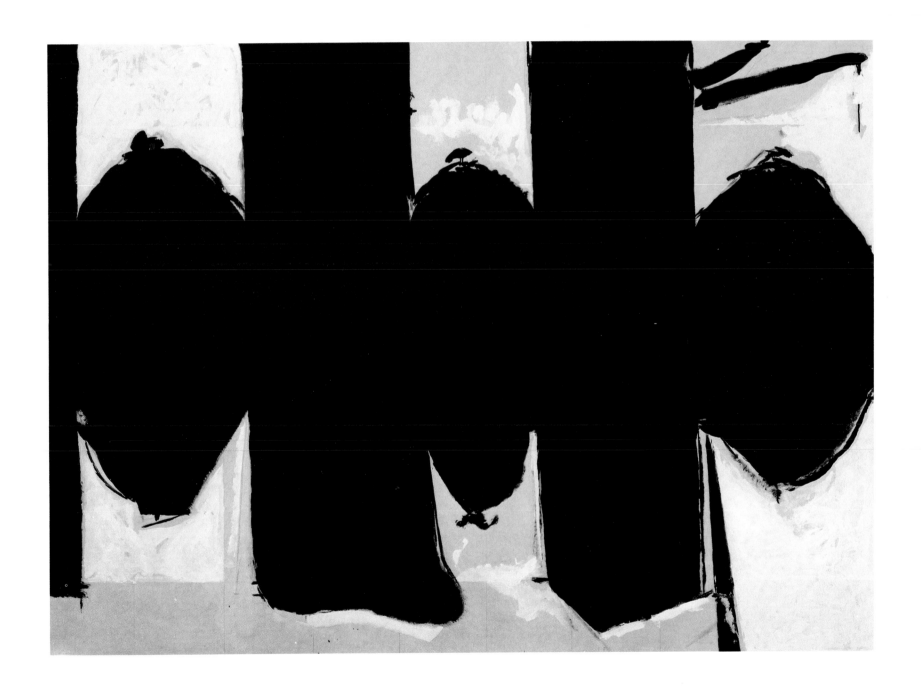

Willem de Kooning

43 *. . . Whose Name Was Writ in Water.* 1975
 Oil on canvas, 76¾ x 87¾ in. (195 x 223 cm.)
 By exchange
 80.2738

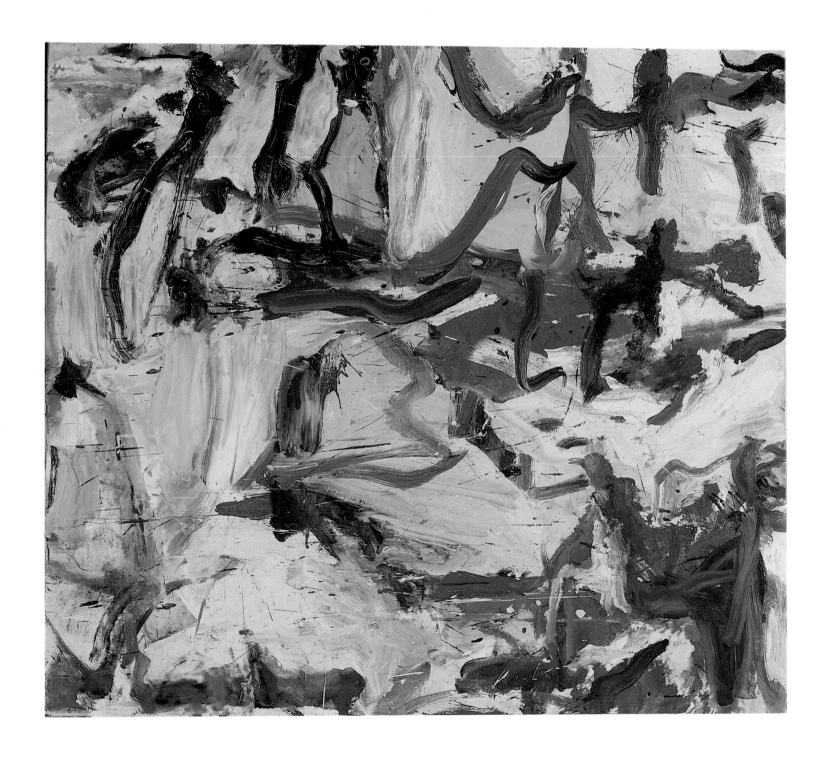

Brice Marden

44 *Grove IV.* **1976**
Oil and wax on canvas, 2 panels, each 36 x 108 in. (91.4 x 274.3 cm.);
total 72 x 108 in. (182.9 x 274.3 cm.)

Purchased with the aid of funds from the National Endowment for the
Arts in Washington, D.C., a Federal Agency; matching funds contributed
by Sidney Singer
77.2288.a, .b

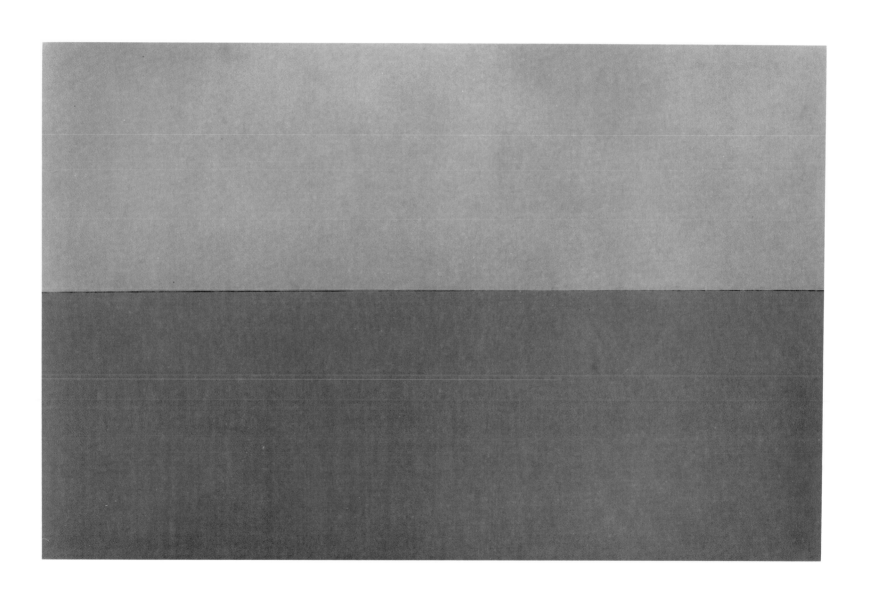

Agnes Martin

45 *Untitled No. 14.* **1977**
 India ink, graphite and gesso on canvas, 72 x 72 in. (182.7 x 182.7 cm.)
 Purchased with funds contributed by Mr. and Mrs. Werner Dannheisser
 77.2336; SRGM hb. 243

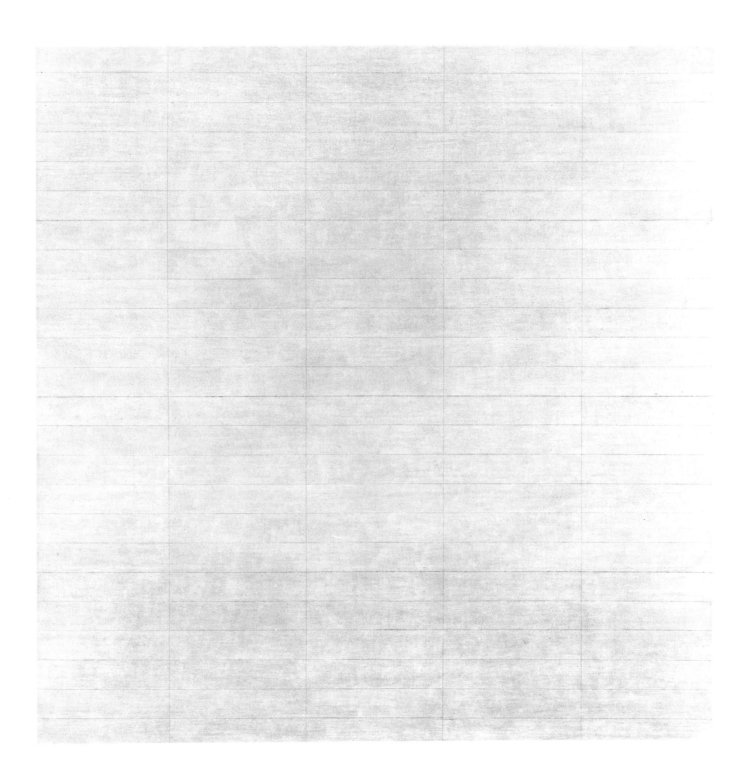

Richard Diebenkorn

46 *Ocean Park No. 96.* 1977
 Oil on canvas, 93⅛ x 85⅛ in. (236.3 x 216.1 cm.)

 Purchased with the aid of the National Endowment for the Arts in
 Washington, D.C., a Federal Agency; matching funds contributed by Mr.
 and Mrs. Stuart M. Speiser and Louis and Bessie Adler Foundation, Inc.,
 Seymour M. Klein, President

 77.2307; SRGM hb. 222

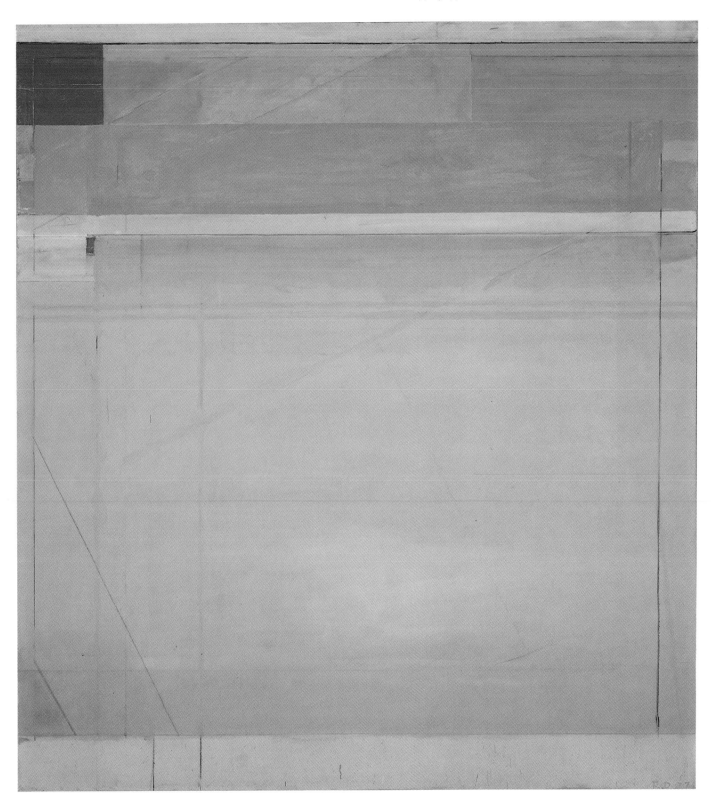

Richard Anuszkiewicz

47 *Soft Violet.* 1981
 Acrylic on canvas, 99 x 66 in. (251.5 x 167.6 cm.)
 Purchased with funds contributed by Mr. and Mrs.
 Edward G. Shufro
 81.2883

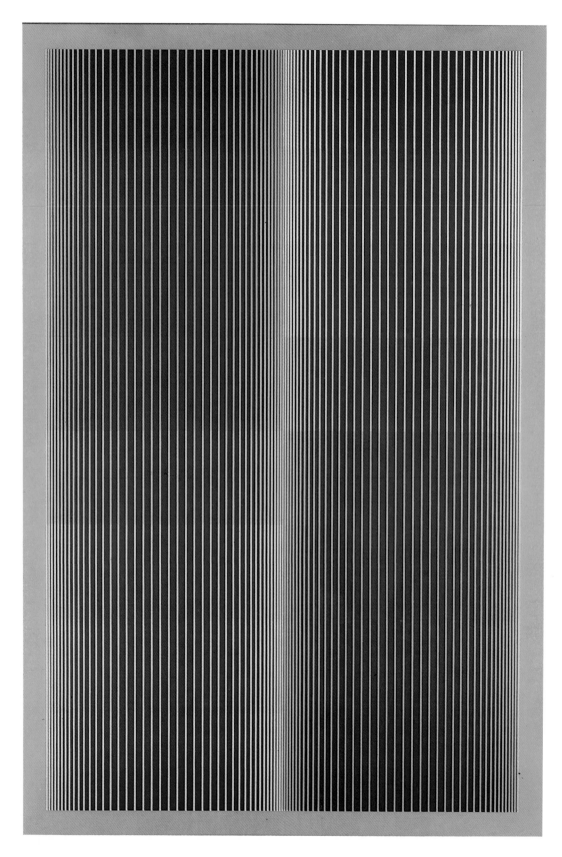

PHOTOGRAPHIC CREDITS

Exhibition 87/6

5000 copies of this catalogue, designed by Malcolm Grear Designers
and typeset by Schooley Graphics/Prime Line Phototype,
have been printed by Arnoldo Mondadori Editore
in September 1987 for the Trustees of The Solomon R. Guggenheim
Foundation on the occasion of the exhibition
Fifty Years of Collecting: An Anniversary Selection.

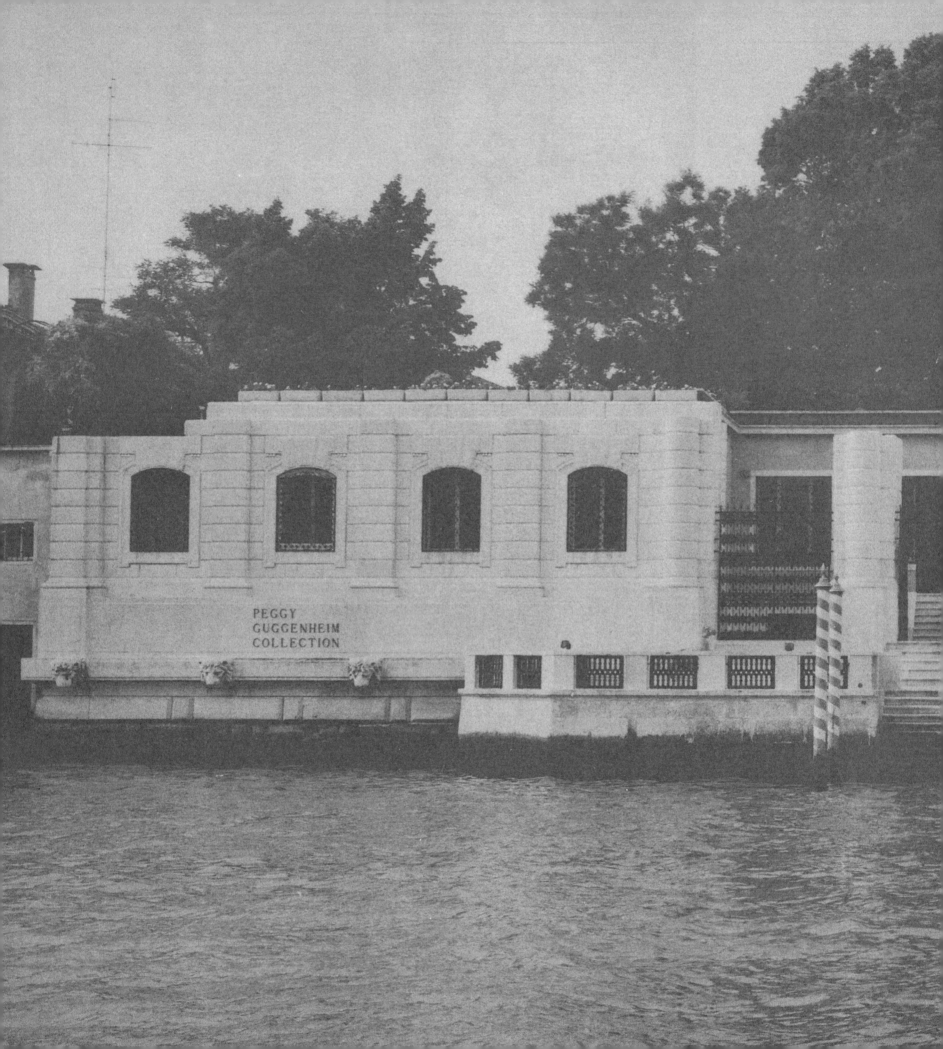